THE ULTIMATE 90'S ALTERNATIVE ROCK QUIZ BOOK

207 Multiple Choice Trivia Questions and Fun Facts to Test Your 90s Rock Knowledge

JON MARSHALL

CONTENTS

SPECIAL NOTE

In addition to general entertainment, this book is for any Trivia MC's to use on Quiz Night. The first half of the book is questions and multiple choice, and the second half is everything - Question, Choices, Answers, and Fun Facts. I hope you find it entertaining, interesting, and useful!

INTRODUCTION

"I was looking for something a lot heavier, yet melodic at the same time. Something different from heavy metal, a different attitude."
-Kurt Cobain

When you call the phrase "alternative rock" to mind, you may think of the 90s, Seattle, grunge, and bands like Pearl Jam, Nirvana, the Smashing Pumpkins, Sonic Youth, and Rage Against the Machine. The moniker "alternative rock" first emerged in the 90s to describe bands that had thrived outside the mainstream. Given that some "alternative" rock bands from Nirvana to Green Day signed to major record labels early in their careers and topped pop charts, it begs the question of what, exactly, defines alternative rock?

Like any cultural phenomenon, alt-rock is a genre that we each define slightly differently. But there's a few agreed-upon elements that may make a group part of alt-rock: a guitar-heavy sound (influenced by the bold sounds of hair bands, glam rockers and metal of the 70s and 80s and pop melodies), and an embrace of a DIY punk-rock, edgy, outside-the-mainstream value system (expressed in lyrics and/or approach to making and distributing music).

When the term "alternative rock" first entered the wider cultural conversation in the 90s, alt-rock groups were still largely defined by local music scenes. Before the mediation of MTV, VH1 or Apple Music, fans connected directly to alt-rock groups through word of mouth or via small local radio stations. Alt-rock emerged from the college rock scene of the 1980s, where groups like R.E.M. had thrived outside of the national spotlight. As the 90s progressed, however, alt-rock bands received increasing mainstream exposure. Bands such as Pavement and The Pixies with cult followings made national airwaves – and gained national fan bases. A slow convergence of sounds from grunge to Britpop connected to the emotions of young people, and many alt-rock artists began outselling most pop artists. The distinct crunchy guitar, angst-filled yet melodic anthems infiltrated the ears of youth everywhere and normalized the counterculture, the weird, the outsider in each of us.

Some may say that the heyday of alt-rock is in the past, and it's true that the early 2000s ushered in the hip hop revolution, a resurgence of pop, and a diffusion of the distinct "alt-rock" genre into more diverse sounds. The advent of today's music streaming services continues to change the music landscape, as artists often find success on YouTube instead of in local clubs. However, alt-rock in various forms continues to be an important force in music as artists of every genre cross-pollinate and certainly many of today's hottest acts pay homage to alt-rock sounds.

For alt-rock fans, the history behind your favorite songs deepens your appreciation of the classics and your ability to understand their influence on today's music. From the inspiration and collaborations behind some of the most influential alt-rock anthems to the behind-the-scenes tragedies that shaped the lives of the artists, the twists and turns of alt-rock are as varied as the music itself. Above all, this book is an homage. For many of us, there's nothing like the first time we heard Pearl Jam or Radiohead. We fans are forever grateful to the pioneering artists whose timeless music speaks to our inner weirdos and lets us fly our freak flags high.

QUIZ QUESTIONS

,

QUESTIONS: 1 - 20

1. What denomination is the banknote on the cover of Nirvana's album, "Nevermind"?

 A. $20
 B. $10
 C. $5
 D. $1

2. Forming in 1989 as Mighty Joe Young, which following band was regularly derided as a rip-off of Pearl Jam?

 A. Soundgarden
 B. Nirvana
 C. Alice in Chains
 D. Stone Temple Pilots

3. With a name derived from a biblical story, "The Last Temptation" was a 1994 concept album by which famous rocker?

A. Steven Tyler

B. Jon Bon Jovi

C. Alice Cooper

D. Chris Cornell

4. According to Layne Stanley, the Alice in Chains song "Man In The Box" is written from the perspective of which animal?

A. Calf

B. Piglet

C. Duckling

D. Lamb

5. Fronted by dreadlocked vocalist Lajon Witherspoon, the band Sevendust was formed in 1994 in which US city?

A. Phoenix

B. Atlanta

C. Chicago

D. Boston

6. Featuring a stylized octopus wearing a crown, "Eight Arms To Hold You" was the second studio album released by which band?

A. Hole

B. Seether

C. Veruca Salt

D. The Smashing Pumpkins

7. The lyrics of Soul Asylum's 1997 hit "Runaway Train" mention which character "laughin' at the rain"?

4

A. A psycho
B. A joker
C. A jackass
D. A madman

8. Released in 2 parts, "The Zephyr Song" by Red Hot Chili Peppers was the second single off which album?

A. Californication
B. By The Way
C. Blood Sugar Sex Magik
D. Mother's Milk

9. When he first formed Jane's Addiction in 1985, who gave frontman Perry Farrell the inspiration for the band's name?

A. His grandmother
B. His sister
C. His housemate
D. His favorite teacher

10. Released on their 1991 self-titled album, the lyrics of Metallica's quasi-somnolent hit "Enter Sandman" mention which fairy tale character?

A. Snow White
B. Cinderella
C. Sleeping Beauty
D. Rapunzel

11. The Smashing Pumpkins have undergone many lineup changes over the past 20+ years, but which of these musicians joined the band most recently?

A. Billy Corgan
B. D'arcy Wrtezky
C. Jeff Schroeder
D. Jimmy Chamberlin

12. Much of the appeal and success of the grunge era can be attributed to the bands collectively referred to as the "Big 4 of Grunge". Which following band was NOT one of the big 4?

A. Foo Fighters
B. Nirvana
C. Pearl Jam
D. Alice in Chains

13. The cover art for the Red Hot Chili Peppers' "One Hot Minute" album features which mythical creature playing a mandolin while sitting atop a piano?

A. A mermaid
B. A leprechaun
C. A pixie
D. A troll

14. With songs such as "Tired of Sex", "The Good Life" and "El Scorcho", what was the title of Weezer's second studio album?

A. Pinkerton
B. Blue Album
C. Green Album

D. Make Believe

15: In the lyrics of "Creep" by Radiohead, the subject of the song is described as looking like what type of celestial being?

 A. God
 B. Angel
 C. Goddess
 D. Cherub

16. Outside his body of work with Soundgarden, Chris Cornell also wrote and performed "Hunger Strike" with which group?

 A. Pigface
 B. Temple of the Dog
 C. Voodoocult
 D. Mad Season

17. Jack Endino is more widely known as a producer for the Sub Pop label, but which band did he play guitar for from 1985-1992?

 A. Gruntruck
 B. Mother Love Bone
 C. Green River
 D. Skin Yard

18. Mentioning Jesus six times, the song "Possum Kingdom" was a 1995 hit for which band?

 A. Toadies
 B. Everclear
 C. Candlebox

D. Bush

19. With a film clip featuring footage from the Vietnam War, which Alice in Chains song begins with the line "Ain't found a way to kill me yet"?

A. Them Bones
B. Rooster
C. Sickman
D. God Smack

20. With lyrics including "When I want something, I don't want to pay for it", "Been Caught Stealing" came from which Jane's Addiction album?

A. Nothing's Shocking
B. Kettle Whistle
C. Ritual de lo Habitual
D. Live and Rare

QUESTIONS: 21 - 40

21. Reaching #37 on the Billboard Modern Rock Chart, "Sweet 69" by Babes in Toyland is noted for the liberal use of which percussion instrument?

A. Cow bell
B. Tambourine
C. Triangle
D. Claves

22. The bassitar *(this is not a typo – pronounced "base-it-tar", rhymes with guitar)* and the guitbass *(not a typo – pronounced "git-base)* which were regular guitars with special modifications and fewer strings - are synonymous with the music of which band?

A. Queens of the Stone Age
B. Smashmouth
C. Offspring
D. Presidents of the United States of America

23. Released in 1999 on the album "A Place in the Sun", "My Own Worst Enemy" was a song by which band?

 A. Lit
 B. Tonic
 C. Blur
 D. Fuel

24. Nirvana's "Smells Like Teen Spirit" is an anthem of the grunge era, but where did the title for the song come from?

 A. It was written on Kurt Cobina's wall by his girlfriend
 B. Dave Grohl saw it written on a toilet door
 C. Kirst Novacelic heard it on TV
 D. Kurt Cobain saw it in a magazine

25. Soundgarden formed in 1984, but which of these guitarists was the only one to appear in every iteration of the band?

 A. Matt Cameron
 B. Kim Thayil
 C. Jason Everman
 D. Ben Shepherd

26. The first Top 40 US hit for the Smashing Pumpkins was a song about what object with butterfly wings?

 A. Missile
 B. Bazooka
 C. Bullet
 D. Grenade

27. With a title very appropriate for the group who recorded it, "Transnational Speedway League" was the 1993 debut album for what band?

 A. Clutch
 B. Brake
 C. Slide
 D. Crash

28. With guest performances by Slash, Nikki Sixx and Ozzy Osbourne, which Alice Cooper album was recorded in the 1990s?

 A. Trash
 B. Raise Your Fist And Yell
 C. Hey Stoopid
 D. Constrictor

29. Marilyn Manson's "Mechanical Animals", Hole's "Celebrity Skin" and Pearl Jam's "Yield" were all albums released in what year of the 1990s?

 A. 1999
 B. 1998
 C. 1997
 D. 1996

30. Released by Columbia Records in 1990, Alice in Chains' debut studio album shares its name with which cosmetic surgery procedure?

 A. Liposuction
 B. Rhinoplasty
 C. Facelift
 D. Dermabrasion

31. Alongside Tim Commerford and Zack de la Rocha, Tom Morella formed Rage Against The Machine after previously playing with which band?

 A. Audioslave
 B. Run the Jewels
 C. Lock Up
 D. Deftones

32. November 1991 saw the release of U2's "Achtung Baby", "Loveless" by My Bloody Valentine and which of these albums?

 A. "Copper Blue" by Sugar
 B. "Dirty" by Sonic Youth
 C. "Lull" by the Smashing Pumpkins
 D. "Wish" by The Cure

33. With songs such as "Low" and Endgame", which R.E.M. album won the band's first Grammy for 'Best Alternative Music Album'?

 A. "Monster"
 B. "New Adventures in Hi-Fi"
 C. "Up"
 D. "Out of Time"

34. First released as a bonus track on their "Angel Dust" album, Faith No More's "Easy" was a cover originally recorded by which band?

 A. Earth, Wind and Fire
 B. The Temptations
 C. The Jackson 5
 D. The Commodores

35. With the song noted for its switches between speaking and singing, which following name is not mentioned in "Pepper" by Butthole Surfers?

 A. Marky
 B. Larry
 C. Bobby
 D. Tommy

36. Releasing their self-titled debut album in 1991, the band Pennywise took their name from a character invented by which author?

 A. Clive Barker
 B. Dean Koontz
 C. Stephen King
 D. James Patterson

37. Also known as The Thunder God for his drumming abilities, how did Def Leppard's Rick Allen lose his left arm?

 A. Cancer
 B. A car accident
 C. A farming accident
 D. Sepsis

38. First covered by Pearl Jam on a charity album in 1999, "Last Kiss" topped the singles chart in which country for 7 weeks?

 A. New Zealand
 B. Australia
 C. Ireland
 D. Sweden

39. As well as being the original vocalist in the Gin Blossoms, Jesse Valenzuela played which instrument in the band?

A. Drums
B. Rhythm guitar
C. Keyboard
D. Bass guitar

40. Which track from Green Day's 1994 "Dookie" album is a hidden track, performed by Tre Cool?

A. In The End
B. Coming Clean
C. Sassafras Roots
D. All By Myself

QUESTIONS: 41 - 60

41. The 1991 compilation album "The Grunge Years" featured "Tomorrow" by Fluid, "Saddle Tramp" by Dickless and which song by Mudhoney?

 A. Come to Mind
 B. You Got It
 C. Here Comes Sickness
 D. When Tomorrow Hits

42. The second single from Weezer's self-titled debut album shares its name with which legend of music?

 A. Elvis Presley
 B. Chubby Checker
 C. Frank Sinatra
 D. Buddy Holly

43. Which song from Nirvana's third studio album "In Utero" was allegedly about an intimate part of Courtney Love's anatomy?

A. Dumb
B. Milk It
C. Heart-shaped Box
D. Very Ape

44. All of the following bands played an iconic role in rock music, but which band was formed most recently?

A. Blur
B. White Zombie
C. Korn
D. Alice in Chains

45. Despite sounding more like a macabre take on a Queen hit, "Somebody to Shove" was recorded by which band in 1992?

A. Goo Goo Dolls
B. Collective Soul
C. Spin Doctors
D. Soul Asylum

46. As well as being a member of the Smashing Pumpkins, which musician is well-known for his role in the governing and promotion of wrestling?

A. Mike Byrne
B. Billy Corgan
C. James Iha
D. Jeff Schroeder

47. The 'Velvet' supergroup featuring members such as Slash, Duff McKagan and Scott Weiland also had what weapon in the band's name?

A. Shotgun
B. Pistol
C. Revolver
D. Handgun

48. Which following word completes the line "Watching, waiting, (blank)" from Blink 18's hit "All the Small Things"?

A. Intimidating
B. Discriminating
C. Commiserating
D. Accelerating

49. Best known as a vocalist for Evanescence, rock goddess Amy Lee is also notable for playing which instrument?

A. Flute
B. Violin
C. Ukulele
D. Harp

50. Iconic grunge song "Smells Like Teen Spirit" was stripped back and covered by which songstress on her "Little Earthquakes" album?

A. Fiona Apple
B. Kate Bush
C. Tori Amos
D. PJ Harvey

51. The lead singer of The Wallflowers is also the fourth child of which folk music legend?

A. Bob Dylan
B. Van Morrison
C. Neil Young
D. Jackson Browne

52. Ben Folds Five's biggest commercial success was "Brick", but what was their first rado single released in 1995?

A. Philosophy
B. Sports and Wine
C. Underground
D. Boxing

53. In their 1996 Grammy-nominated song, how many "Peaches" did the Presidents of the United States of America sing about?

A. Thousands
B. Heaps
C. Hundreds
D. Millions

54. Rock legend Dave Grohl played drums for Nirvana, fronted the Foo Fighters and also founded which following supergroup?

A. Them Crooked Vultures
B. Atoms For Peace
C. Tinted Windows
D. Dead By Sunrise

55. Recorded on the band's third and final album was Nirvana's song about what which following substance?

 A. Pennyroyal tea
 B. Rosewater
 C. St John's Wort
 D. Witch-hazel

56. Fronted by Wes Scantlin and having a debut album entitled "Abrasive", which following band formed in Kansas City in September 1991?

 A. Staind
 B. Puddle of Mudd
 C. Seether
 D. Theory of a Deadman

57. The cover of Pulp's "Different Class" album featured a wedding congregation, including bridesmaids wearing what colored dresses?

 A. Red
 B. Blue
 C. Pink
 D. Yellow

58. The lyrics of which Alice in Chains song featured the refrain "One who doesn't care, is one who shouldn't be"?

 A. Junkhead
 B. No Excuses
 C. Dirt
 D. Rotten Apple

59. Footage from iconic TV show "Happy Days" was used in a 1994 video clip by which band?

 A. Green Day
 B. Presidents of the United States of America
 C. Weezer
 D. Offspring

60. With the last line "She's my one and only", Which following Smashing Pumpkins song came from "Mellon Collie and the Infinite Sadness"?

 A. Zero
 B. Quiet
 C. Soma
 D. Rocket

QUESTIONS: 61 - 80

61. Fronted by the infamously quarrelling Gallagher brothers, Oasis were formed in 1991 in which English city?

A. Birmingham
B. Manchester
C. Liverpool
D. Sheffield

62. First formed in London in 1988 and helping establish the Britpop genre, Blur released which of these albums first?

A. Modern Life Is Rubbish
B. Leisure
C. The Great Escape
D. Parklife

63. In 1991, which band collaborated with metal outfit Anthrax to remake the hit song "Bring the Noise"?

A. Public Enemy
B. Run-D.M.C.
C. Beastie Boys
D. N.W.A

64. A side project of several 1990's grunge bands, the band Mad Season did not include which of these musicians?

A. Layne Staley
B. Eddie Vedder
C. Mike McCready
D. Barrett Martin

65. Which following reptile is mentioned in "Black Hole Sun", the 3rd single from Soundgarden's "Superunknown" album?

A. Snake
B. Lizard
C. Turtle
D. Alligator

66. Prior to releasing their "Uncle Anesthesia" album in 1991, the Screaming Trees signed with which major record label?

A. Impact Records
B. Redbird Records
C. Epic Records
D. Virgin Records

67. Founded in Seattle in 1986, which following record label became synonymous with early 90's grunge music?

A. Crammed Discs
B. Autumn Records
C. Sub Pop
D. Virus Music

68. Also known by the first names Foo and Ted, Matt Cameron famously played drums for Soundgarden and which other band?

A. Smashing Pumpkins
B. Alice in Chains
C. Pearl Jam
D. Weezer

69. Nirvana's Kurt Cobain and Alice in Chains' Layne Staley both died on which date, 8 years apart?

A. November 6
B. June 4
C. April 5
D. February 7

70. First staged in 1991, which following music festival is noted for giving stage time to many grunge and alternative rock bands?

A. Lollapalooza
B. Reading Festival
C. Beale Street
D. Warped

71. Which band, influential in the grunge and alternative metal genres, lost their frontman to a heroin overdose shortly before their first major release?

A. White Zombie

B. Talking Heads

C. Green River

D. Mother Love Bone

72. Born Mark Thomas McLaughlin in 1962, Mark Arm sang with which other band prior to fronting rock band Mudhoney?

A. Malfunkshun

B. The U-Men

C. Green River

D. The Melvins

73. With songs such as "Reach Down" and "Say Hello 2 Heaven", Temple of the Dog was conceived as a tribute to which musician?

A. Andrew Wood

B. Mike Starr

C. Kurt Cobain

D. Scott Weiland

74. One of the most accomplished music producers of his time, Rob Cavallo is widely known for his work with which of these bands?

A. Fall Out Boy

B. Green Day

C. Linkin Park

D. The Offspring

75. Prior to forming Sweet 75 and Eyes Adrift, Krist Novoselic was a bassist and founding member of which band?

A. Metallica
B. Foo Fighters
C. Nirvana
D. Pixies

76. The final single off the album "Transistor", "Beautiful Disaster" was a song by a band with which numerical name?

A. 311
B. 269
C. 194
D. 457

77. Widely acknowledged as one of the greatest guitarists in music history, Slash from Guns N Roses started which side project in 1994?

A. Slash's Torture Chamber
B. Slash's Snakepit
C. Slash's Hellpit
D. Slash's House of Pain

78. With music written by John Frusciante and Flea, "Give It Away" by Red Hot Chili Peppers was the lead song from which album?

A. Mother's Milk
B. One Hot Minute
C. Blood Sugar Sex Magick
D. Californication

79. Released in 1992 under the Interscope Records Label, the first EP by Nine Inch Nails had what following title?

A. The Fragile

B. Broken

C. With Teeth

D. Pretty Hate Machine

80. The cover of Soundgarden's "Badmotorfinger" album features the album name written in white lettering inside which geometric shape?

A. Triangle

B. Square

C. Circle

D. Star

QUESTIONS: 81 - 100

81. Also known as Gamma Ray, the Queens of the Stone Age were founded in 1996 by which following musician.

 A. Troy Van Leeuwen

 B. Joey Castillo

 C. Josh Homme

 D. Mark Lanegan

82. Before Nickelback gained widespread success in the rock genre, they performed as a grunge cover band with what name?

 A. Local Hero

 B. Court Jester

 C. Village Idiot

 D. Crooked Cousin

83. Best known for the 1996 song "Counting Blue Cars", rock band Dishwalla hailed from which Californian city?

A. Santa Barbara
B. Long Beach
C. San Jose
D. Modesto

84. Named after an alternative school in Minneapolis, the band Marcy Playground is widely regarded as a one-hit wonder for which 1997 song?

A. Love and Rockets
B. Sex and Candy
C. Hot and Sweaty
D. Alive and Kicking

85. Currently fronted by long-standing member Brett Scallions, Fuel toured extensively with which band in 1998?

A. The Verve
B. Creed
C. The Cure
D. Hootie and the Blowfish

86. The lyrics "All across the alien nation, where everything isn't meant to be ok" come from which Green Day song?

A. Burnout
B. Hitchin' A Ride
C. American Idiot
D. Reject

87. As heard in the lyrics of 1994's "Lightning Crashes" by Live, what type of being "opens her eyes"?

A. Angel

B. Mermaid

C. Demon

D. Fairy

88. First released independently in 1997, what title was given to the debut studio album by rock band Creed?

A. Full Circle

B. Weathered

C. Human Clay

D. My Own Prison

89. According to the lyrics of "Self-Esteem" by The Offspring, what time does the singer wait until before he decides to "turn out the light"?

A. 4

B. 3

C. 2

D. 1

90. In the title of their third studio album from 1994, rock band Live were "throwing" what type of metal?

A. Bronze

B. Silver

C. Lead

D. Copper

91. Released in 1993, "Everyone Else Is Doing It, So Why Can't We?" is an album by which female-fronted rock band?

A. No Doubt

B. Hole

C. The Cranberries

D. Garbage

92. Based on a bout of mononucleosis suffered by the band's lyricist, "Down with Disease" was a song by which following band?

A. Placebo

B. Weezer

C. Phish

D. Korn

93. The cover of Marilyn Manson's 3rd album "Mechanical Animals" features the singer with a streak of what color in his hair?

A. Blue

B. Green

C. Red

D. Yellow

94. Featuring the single "Pull Me Under", what was the title of the album released by Dream theater in 1992?

A. Images and Words

B. Letters and Numbers

C. Signs and Symbols

D. Noughts and Crosses

95. "I know who I want to take me home" is a refrain heard in which rock song released in 1998?

A. Fly Away

B. Closing Time

C. Never There

D. Inside Out

96. What following name is shared by a James Bond film and the band who recorded "Here in Your Bedroom" in 1996?

A. Goldfinger

B. Octopussy

C. Thunderball

D. Moonraker

97. Marilyn Manson's 1995 "Smells Like Children" album featured a cover of which popular song?

A. Wake Me Up (Before You Go-Go)

B. (I Can't Get No) Satisfaction

C. Sweet Dreams (Are Made Of This)

D. Break On Through (To The Other Side)

98. Before gaining success under their final name, which following band were once known as Small the Joy?

A. Cake

B. Fuel

C. Poison

D. Motorhead

99. Released on the band's only studio album, which "Temple of the Dog" song opened with the line "I don't mind stealin' bread"?

A. Hunger Strike

B. Reach Down

C. Wooden Jesus

D. Your Saviour

100. Releasing 7 albums over 20 years, the band Seven Mary Three took the inspiration for their name from which TV show?

A. Hawaii Five-0

B. Hill Street Blues

C. CHiPs

D. Starsky & Hutch

QUESTIONS: 101 - 120

101. The Offspring's sixth studio album, "Conspiracy Of One", featured a yellow flaming skull on a background circle of which color?

 A. Yellow
 B. Red
 C. Purple
 D. Green

102. Released independently by Beck in 1993, which following song featured the line "Don't believe everything that you breathe"?

 A. Lemon
 B. Linger
 C. Low
 D. Loser

103. The lyrics "Sometimes it's my life I can't taste" came from which song on Korn's "Follow the Leader" album?

A. Freak on a Leash

B. Got the Life

C. Reclaim My Place

D. Dead Bodies Everywhere

104. With lyrics such as "You're a slave to money then you die", what kind of 'Symphony' did The Verve sing about in 1997?

A. Melancholy

B. Bitter Sweet

C. Poignant

D. Wistful

105. Pioneers of the grunge era, brothers Gary and Van from the Screaming Trees had what surname?

A. Connolly

B. Conroy

C. Conlon

D. Conner

106. Released on the "Use Your Illusion 1" album was a Guns N Roses song featuring which month in the title?

A. February

B. April

C. September

D. November

107. When Pantera released their fifth album in 1990, what type of characters were mentioned in the title?

A. Indians

B. Cowboys

C. Thieves

D. Spacemen

108. In a 1991 song by Primus, what was the name of the racecar driver who "drove so goddamn fast"?

A. Donny

B. Jerry

C. Ronny

D. Terry

109. The original bassist for Alice in Chains, Mike Starr was replaced by which musician in 1993?

A. William DuVall

B. Jerry Cantrell

C. Mike Inez

D. Sean Kinney

110. After "Hole" was founded in 1989 by Courtney Love and Eric Erlandson, which female musician was never part of the lineup?

A. Suzi Gardner

B. Patty Schemel

C. Melissa Auf der Maur

D. Kristen Pfaff

111. In the lyrics of "Mr Jones" by Counting Crows, the subject of the song painted themselves in "blue and red and black" and what other color?

A. Green

B. Grey

C. Brown

D. White

112. With a heavy emphasis on alternative rock, the soundtrack for "Last Action Hero" did not feature which of these bands?

A. Megadeth

B. Anthrax

C. Korn

D. Aerosmith

113. Covered by artists including Kelly Clarkson, The Corrs and Pink, REM's "Everybody Hurts" was originally on which album?

A. Automatic for the People

B. Out of Time

C. Monster

D. Up!

114. According to the lyrics of her smash hit "You Oughta Know", Alanis Morisette sings of the "mess you made when you..." did what?

A. Disappeared

B. Took off

C. Went Away

D. Went to jail

115. "They hold the reins and stole your eyes" is a lyric from Rage Against the Machine's "Guerilla Radio", but what album did the track come from?

A. Rage Against the Machine

B. Evil Empire

C. The Battle of Los Angeles

D. Renegades

116. With its title taken from the first line of the song, "If You Could Only See" was a hit for which following band?

A. Collective Soul

B. Dishwalla

C. Tonic

D. Blur

117. They Might Be Giants released a single in 1990 with what animal accommodation in the title?

A. Pig pen

B. Dog kennel

C. Bird house

D. Chicken Coop

118. Written by Gwen Stefani and Tom Dumont, "Just a Girl" was released on which No Doubt album?

A. Tragic Kingdom

B. The Beacon Street Collection

C. Return of Saturn

D. Rock Steady

119. In 1995, which band released a song that opened with the line "I am the Astro-Creep, a demolition style hell American freak yeah"?

A. Danzig
B. White Zombie
C. Faith No More
D. Testament

120. According to Matchbox 20 in the lyrics of "3AM", what emotion is described as a "mat that sits on her doorway"?

A. Euphoria
B. Delirium
C. Happiness
D. Contentment

QUESTIONS: 121 - 140

121: Reaching #1 in 3 different countries, "Iris" by the Goo Goo Dolls was originally written for the soundtrack of which 1998 movie?

 A. What Dreams May Come
 B. Sliding Doors
 C. Pleasantville
 D. City of Angels

122: The film clip for which song off the Stone Temple Pilots' "Purple Album" features a silent movie for the first 40 seconds?

 A. Lounge Fly
 B. Interstate Love Song
 C. Vasoline
 D. Big Empty

123: Featured on the album "Without You I'm Nothing", which Placebo song starts with the line "Sucker love is heaven sent, you pucker up, our passion's spent"?

A. You Don't Care About Us
B. My Sweet Prince
C. Every You, Every Me
D. Scared of Girls

124: Released in 1998 and featuring the hit single "Space Lord", what was the title of Monster Magnet's fourth album?

A. Egotrip
B. Powerhungry
C. Egomaniac
D. Powertrip

125: Formed in Canada in 1992, rock band Our Lady Peace has been fronted by which member since its inception?

A. Steve Mazur
B. Raine Maida
C. Jason Pierce
D. Duncan Coutts

126: Regarded as their most popular work, which band released the album "Bringing Down the Horse" in 1996?

A. The Wallflowers
B. Toad the Wet Sprocket
C. Counting Crows
D. Third Eye Blind

127: Achieving multi-platinum success with their second album "New Miserable Experience", the Gin Blossoms hailed from which American state?

A. Virginia

B. Arizona

C. Georgia

D. Massachusetts

128: In the lyrics of the Soundgarden song "Spoonman", the singer compares all his friends to which creepy characters?

A. Ghosts

B. Skeletons

C. Demons

D. Monsters

129: After signing with Interscope Records, which band released the album "Broken" in 1992?

A. Nine Inch Nails

B. Tool

C. Jane's Addiction

D. Deftones

130: Prior to his untimely death due to heart attack on stage in 1999, Mark Sandman was lead singer for which band?

A. Morphine

B. Portishead

C. Cowboy Junkies

D. Iron Maiden

131: Covered by Guns N' Roses on their "Use Your Illusion 1" album, the song "Live and Let Die" was written by which former Beatles member?

A. John Lennon
B. Ringo Starr
C. George Harrison
D. Paul McCartney

132: Prior to achieving success under their current name, the band Linkin Park were known by what name?

A. Phantaxm
B. Xanax
C. Baxaar
D. Xero

133: Released in July 1993, the Smashing Pumpkins' second studio album was about what kind of "Dream"?

A. Taiwanese
B. Siamese
C. Japanese
D. Burmese

134: 1991 was quite the year for rock music, but which of these bands was not formed in that year?

A. Cake
B. Incubus
C. Oasis
D. Creed

135: First formed in 1996 and headed up by the Madden twins, where did the band Good Charlotte get the inspiration for their name?

A. A children's book
B. A TV show
C. A childhood friend
D. A movie

136: With all members having been with the band since inception, which musician sings lead vocals for Simple Plan?

A. Chuck Comeau
B. Pierre Bouvier
C. Jeff Stinco
D. Sebastian Lefebvre

137: Featured on the band's "Californication" album, which Red Hot Chili Peppers track contains the refrain "With the birds I'll share this lonely viewin' "?

A. Around the World
B. Otherside
C. Scar Tissue
D. Parallel Universe

138: Releasing their debut album in 1992, the Manic Street Preachers hail from which country of the UK?

A. Wales
B. Scotland
C. Ireland
D. England

139: What are the first names of the twin sisters who both sing and play guitar for The Breeders?

A. Kat and Kasey
B. Kylie and Kirsty
C. Kate and Krystal
D. Kim and Kelley

140: Recorded on R.E.M's "Monster" album was a track with what male name in the title?

A. Matthew
B. Kenneth
C. David
D. Roger

QUESTIONS: 141 - 160

141: Which common substance is also the title of a Bush song from 1995?

A. Peroxide

B. Lanolin

C. Borax

D. Glycerine

142: Released in 1993, "Undertow" was the debut studio album by which rock band?

A. Tool

B. Suede

C. Extreme

D. Eightball

143: English musician Jarvis Cocker found fame as the frontman of Pulp, but what accessory became part of his trademark appearance?

A. Bow tie
B. Walking stick
C. Beret
D. Glasses

144: Appearing on the band's 1992 "Dirt" album, which Alice in Chains song was a tribute to the lead vocalist of Mother Love Bone?

A. Would?
B. Junkhead
C. Sickman
D. Angry Chair

145: The members of which following band met while attending the same school in England?

A. Radiohead
B. Gorillaz
C. Blur
D. The Verve

146: Known for the 1992 album "The Southern Harmony and Musical Companion" is which band hailing from Marietta, Georgia?

A. The White Doves
B. The Black Crowes
C. The Screaming Eagles
D. The Flaming Peacocks

147: What title was given to the lead single from Blur's third album, "Parklife"?

A. Men & Women
B. Ladies & Gentlemen
C. Chicks & Guys
D. Girls & Boys

148: Featuring the lyrics "Flip on the telly, wrestle with Jimmy" was which 1994 Weezer song?

A. My Name is Jonas
B. Only In Dreams
C. Say It Ain't So
D. No One Else

149: Prior to leaving the music industry to pursue a career as a visual artist, Justine Frischmann was the lead singer of which band?

A. Elastica
B. Suede
C. Republica
D. Lash

150: The cover of Oasis album "(What's the Story) Morning Glory?" features two men on which iconic London roadway?

A. Abbey Road
B. Berwick Street
C. Brick Lane
D. Piccadilly

151: Alternative rock band The Boo Radleys took their name from a character in which classic novel?

A. The Catcher In The Rye
B. Slaughterhouse-Five
C. To Kill a Mockingbird
D. Animal Farm

152: Which following rock band formed in 1993 includes brothers Gaz and Rob Coombes?

A. The Hotrats
B. Pulp
C. Supergrass
D. Primal Scream

153: Which following band were forced to change their name after drawing unwanted attention from a similar-named irish band?

A. Blink-182
B. The Offspring
C. Good Charlotte
D. Ben Folds Five

154: What was the title of the Ramones 14th and final studio album, released in 1995?

A. So Long, and Thanks for All the Fish
B. Adios Amigos!
C. Good Riddance
D. Smell Ya Later

155: Which following Pearl Jam track was not included on the band's 1992 "MTV Unplugged in New York" album?

A. On a Plain

B. Dumb

C. Garden

D. Polly

156: Which of the following rock groups did not hail from California?

A. Jane's Addiction

B. Green Day

C. Rage Against The Machine

D. Veruca Salt

157: Released in October 1994, "Cigarettes & Alcohol" was a single by which British band?

A. The Stone Roses

B. Pulp

C. The Verve

D. Oasis

158: Best known as a rhythm guitarist for the Foo Fighters, Pat Smear was the touring guitarist for which band from 1993 to 1994?

A. Alice in Chains

B. Nirvana

C. Guns N' Roses

D. Poison

159: The song "Karma Police" was released as the second single from which Radiohead album?

A. Kid A

B. The Bends
C. OK Computer
D. Amnesiac

160: The first verse of the Korn "Shoots and Ladders" has lyrics taken from which nursery rhyme?

A. Ring Around The Rosie
B. Three Blind Mice
C. Baa Baa, Black Sheep
D. Rock-a-bye Baby

QUESTIONS: 161 - 180

161. Which superhero is mentioned in the title of a track from the Flaming Lips album, "The Soft Bulletin"?

A. Batman

B. Wonder Woman

C. Superman

D. Catwoman

162. Which of the following is both a 1992 song by Indigo Girls, and a character mentioned in Queen's "Bohemian Rhapsody"?

A. Galileo

B. Scaramouche

C. Figaro

D. Beelzebub

163. Which word beginning with R was also the name of the lead single from New Order's 1993 album?

A. Remorse

B. Revenge

C. Regret

D. Repentance

164. The cover of Blur's 1994 "Parklife" album featured images of which dog breed?

A. Dachshund

B. Greyhound

C. Chihuahua

D. Alsatian

165. The lyrics "Little fish, big fish, swimming in the water. Come back here, man, gimme my daughter" form the opening line from a song by which artist?

A. Edie Brickell

B. PJ Harvey

C. Regina Spektor

D. Kate Bush

166. The song "Army of Me" by Bjork was featured in which 1995 movie?

A. GoldenEye

B. Tank Girl

C. Major Payne

D. Mortal Kombat

167. Which Metallica song opens with the lyrics "So close, no matter how far, couldn't be much more from the heart"?

A. Enter Sandman

B. The Unforgiven

C. Sad But True

D. Nothing Else Matters

168. Which band, formed in LA in 1990, is best-known for the 1993 hit "No Rain"?

A. Mother Love Bone

B. Blind Melon

C. Stone Temple Pilots

D. Mad Season

169. What do rock band U2 urge listeners to do in the refrain of their 1991 hit "One"?

A. Love One Another

B. Carry Each Other

C. Help Each Other

D. Stick Together

170. Which female singer had her first brush with fame when she won a radio contest to perform with Shania Twain in 1999?

A. Katy Perry

B. Michelle Branch

C. Nelly Furtado

D. Avril Lavigne

171. According to the lyrics of Nirvana's hit "Come As You Are", you can "come, doused in mud, soaked in…" which substance?

A. Wine

B. Bleach

C. Blood

D. Sweat

172. A huge hit in 1999, the song "Smooth" was a collaboration between Carlos Santana and the frontman of which band?

A. Nickelback

B. Goo Goo Dolls

C. Matchbox 20

D. 3 Doors Down

173. Released in 1998, Aerosmith's "I Don't Want To Miss A Thing" was used in which following movie?

A. Armageddon

B. Deep Impact

C. City of Angels

D. Hope Floats

174. Which following name is not mentioned in the first verse of Sheryl Crow's "All I Wanna Do"?

A. Mac

B. Joey

C. Buddy

D. Billy

175. In 1999, the Cardigans collaborated with which singer in a cover of the Talking Heads song "Burning Down The House"?

A. Neil Sedaka
B. Tom Jones
C. Barry Manilow
D. Tony Bennett

176. As heard in the Barenaked Ladies hit "One Week", it's been "One week since you looked at me", but how long since you "laughed at me"?

A. 5 days
B. 12 days
C. 4 days
D. 6 days

177. All of these songs reached #1 on the Billboard Modern Rock Tracks charts in the 90s, but which one was released the earliest?

A. Daughter - Pearl Jam
B. 1979 - Smashing Pumpkins
C. Sex and Candy - Marcy Playground
D. Give It Away - Red Hot Chili Peppers

178. Which following Green Day song was not on their 1995 "Insomniac" album?

A. Geek Stink Breath
B. No Pride
C. Basket Case
D. Brat

179. Many rock musicians are known as much for meeting their demise prematurely as they are for their musical prowess. Which of these rock musicians died the youngest?

A. Jeff Buckley
B. Andrew Wood
C. Kurt Cobain
D. Freddie Mercury

180. What question did Blink 182 ask in the lead track off their "Enema of the State" album?

A. What's Your Name?
B. What's Going On?
C. What's Happening Next?
D. What's My Age Again?

QUESTIONS: 181 - 207

181. Released in 1990, what was the medical-sounding title of Judas Priest's twelfth studio album?

A. Bandage
B. Painkiller
C. Anaesthetic
D. Tranquilizer

182. Certified 3 times platinum in the U.S., "Tidal" was a 1996 album by which female singer?

A. PJ Harvey
B. Bjork
C. Feist
D. Fiona Apple

183. What breakfast cereal was included in the title of one of Tori Amos' signature tracks, released in 1994?

A. Cornflakes

B. Cheerios

C. Rice Krispies

D. Lucky Charms

184. 4 Non Blondes achieved chart success in 1993 with which single?

A. What's Up?

B. Spaceman

C. Morphine & Chocolate

D. Pleasantly Blue

185. Formed in 1993 in Madison, Wisconsin, Garbage is fronted by which female vocalist?

A. Chrissie Hynde

B. Shirley Manson

C. Courtney Love

D. Delores O'Riordan

186. "Sparkle and Fade" was the first album released under Capitol Records by which band?

A. Wheatus

B. Gin Blossoms

C. Everclear

D. Collective Soul

187. First formed in 1983 and active in the 90's, which following band is one of the 'Big 4' of American thrash metal?

A. Overkill

B. Dark Angel

C. Destruction

D. Megadeth

188. What sea creature was mentioned in the title of the third studio album by Limp Bizkit?

A. Octopus

B. Starfish

C. Dolphin

D. Sea urchin

189. In 1996, David Lee Roth temporarily reunited with which band that he'd originally left in the mid-1980s?

A. Motley Crue

B. Van Halen

C. Def Leppard

D. Bon Jovi

190. Which of these alcoholic beverages is not mentioned in the lyrics of Chumbawumba's "Tubthumping"?

A. Vodka

B. Bourbon

C. Lager

D. Cider

191. Prior to solo success with her albums "Debut" and "Post", Icelandic singer Bjork was a member of which band?

A. The Coffee Beans
B. The Teabags
C. The Sugarcubes
D. The Honeypots

192. Famously used as the "Friends" theme song, "I'll Be There For You" was recored by a band with which 'artistic' name?

A. The Rembrandts
B. The Van Goghs
C. The Monets
D. The Picassos

193. In 1998, the Offspring thought they were "Pretty Fly" for what kind of guy?

A. An old guy
B. A young guy
C. A white guy
D. A tall guy

194. Originally released in 1998, the film clip from which following song features a stylised fetus in utero singing the lyrics?

A. Closing Time
B. Fly Away
C. Teardrop
D. Slide

195. According to the lyrics of Sinead O'Connor's "Nothing Compares 2 U", it's been 7 hours and how many days?

A. 13

B. 15

C. 19

D. 16

196. What name is shared by an Ozzy Osbourne album released in 1991, and a disco song released in 1979?

A. Le Freak

B. September

C. No More Tears

D. Night Fever

197. Which following Alanis Morissette song was not from her "Jagged Little Pill" album?

A. Uninvited

B. Forgiven

C. You Learn

D. Head Over Feet

198. The cover art of "The Fat of the Land" by The Prodigy features which animal, gesturing aggressively?

A. Octopus

B. Shark

C. Starfish

D. Crab

199. The cover of Hole's 1994 'Live Through This' album features model Leilani Bishop dressed up as what type of character?

A. A prom queen
B. A nun
C. A witch
D. A nurse

200. UK band The Prodigy became known for their logo that featured which insect?

A. Butterfly
B. Lady bug
C. Bee
D. Ant

201. Which of the following bands did not contribute to the 1988 "Sub Pop 200" compilation?

A. Green River
B. Fastbacks
C. Nirvana
D. Alice In Chains

202. As a veteran of the Seattle music scene. Which of the following bands did Van Conner never play with?

A. Solomon Grundy
B. Screaming Trees
C. Mad Season
D. Beat Happening

203. Which of the following bands did not originate from the Seattle grunge rock music scene

A. Mother Love Bone
B. Sunny Day Real Estate
C. Green River
D. The Smashing Pumpkins

204. Imaginary records released a Velvet Underground tribute album in 1993 entitled "Fifteen Minutes" What song did the Screaming Trees record for that album?

A. She's my best friend
B. What goes on
C. Pale Blue Eyes
D. I heard her call my name

205. Who said that he wanted to do something like The Beatles did with their album "Sgt. Peppers Lonely Hearts Club Band" , which in his own words "was a massive progression"?

A. Eddie Vedder
B. Chris Cornell
C. Scott Weiland
D. Kurt Cobain

206. Which of the following bands did not include one of Soundgarden's former bass players?

A. Mudhoney
B. Truly
C. Nirvana
D. Hater

207. What is the first EP in music history to debut at Number 1 on the Billboard's 200 chart?

A. Alice In Chains - "Jar of Flies"
B. My Bloody Valentine - "Tremolo"
C. Slowdive's self-titled EP "Slowdive"
D. Pavement - "Watery, Domestic"

ANSWERS AND FUN FACTS

ANSWERS AND FUN FACTS: 1 - 20

1. What denomination is the banknote on the cover of Nirvana's album, "Nevermind"?

A. $20
B. $10
C. $5
D. $1

Answer: D. $1

The banknote on the cover of "Nevermind" was a $1 bill. The swimming infant was Spencer Elden, who was just a few months old when the cover art was shot by a friend of his father. Now age 30, Elden is an artist and entrepreneur. To mark the 25th anniversary of "Nevermind", Spencer recreated the famous image - wearing shorts this time! - in the same swimming pool as the original photo.

2. Forming in 1989 as Mighty Joe Young, which following band was regularly derided as a rip-off of Pearl Jam?

A. Soundgarden

B. Nirvana

C. Alice in Chains

D. Stone Temple Pilots

Answer: D. Stone Temple Pilots

In their early days, the Stone Temple Pilots were regularly accused of trying to be another Pearl Jam, mainly due to perceived similarities between the vocal styles of Scott Weiland and Eddie Vedder. Over time, however, STP's style and sound evolved and diversified. Their 1996 "Tiny Music" album is the best example of this, with a sound that was drastically different to the band's previous material.

3. With a name derived from a biblical story, "The Last Temptation" was a 1994 concept album by which famous rocker?

A. Steven Tyler

B. Jon Bon Jovi

C. Alice Cooper

D. Chris Cornell

Answer: C. Alice Cooper

Released in July 1994, "Last Temptation" was Alice Cooper's 13th solo studio album. Cooper collaborated with several musicians to produce the album - Chris Cornel sang and co-wrote 2 songs, Dan Wexler co-wrote 4 songs and Derek Sherinian played keyboards. As such, the album sounded vastly different from its predecessors, and is considered by many critics to be among Cooper's greatest works.

4. According to Layne Stanley, the Alice in Chains song "Man In The Box" is written from the perspective of which animal?

A. Calf

B. Piglet
C. Duckling
D. Lamb

Answer: A. Calf

"Man In The Box" is a track off Alice in Chains' debut album, and was released as a single in January, 1991. Layne Staley was inspired to create the song after he dined with a group of vegetarians. He'd been thinking and writing and censorship, and was struck by the similarity between calves being raised in small boxes, and humans being fed information by the government and the media.

5. Fronted by dreadlocked vocalist Lajon Witherspoon, the band Sevendust was formed in 1994 in which US city?

A. Phoenix
B. Atlanta
C. Chicago
D. Boston

Answer: B. Atlanta

The band that would eventually become Sevendust began when Vince Hornsby, Morgan Rose and John Connolly started performing together under the name Snake Nation. Lajon Witherspoon and Clint Lowery joined the group after their first demo was recorded, and they renamed themselves Rumblefish. Upon discovering another band with the same name, they changed their name to Crawlspace, only to have the same thing happen again. The band's eventual name was inspired by a brand of commercial insecticide.

6. Featuring a stylized octopus wearing a crown, "Eight Arms To Hold You" was the second studio album released by which band?

A. Hole
B. Seether
C. Veruca Salt
D. The Smashing Pumpkins

Answer: C. Veruca Salt

"Eight Arms To Hold You" was released by Veruca Salt in February, 1997. The inspiration for the album's title came from the working title of the Beatles' film,"Help!". The album only peaked at #55 on the Billboard 200, but the single "Volcano Girls" became a hit. "Eight Arms To Hold You" was also the last album until 2015 to feature all the band's original members.

7. The lyrics of Soul Asylum's 1997 hit "Runaway Train" mention which character "laughin' at the rain"?

A. A psycho
B. A joker
C. A jackass
D. A madman

Answer: D. A madman

The full line mentioned in the question was "Like a madman laughin' at the rain, a little out of touch, a little insane". Soul Asylum's lead singer Dave Pirner originally wrote the song about his first-hand experiences with depression, and the film clip is well-known for featuring images of children and young people who had been reported missing. The song went on to win the 1994 Grammy Award for Best Rock Song.

8. Released in 2 parts, "The Zephyr Song" by Red Hot Chili Peppers was the second single off which album?

A. Californication

B. By The Way
C. Blood Sugar Sex Magik
D. Mother's Milk

Answer: B. By The Way

"The Zephyr Song" was written as an ode to the healing power of nature and human connection, and both editions of the single included multiple new B-side tracks. The single only peaked at #6, ending the band's string of number 1 hits. Coincidentally, the 3-note guitar riff at the beginning of the song comprises the first 3 notes of "Pure Imagination" from "Willie Wonka and the Chocolate Factory".

9. When he first formed Jane's Addiction in 1985, who gave frontman Perry Farrell the inspiration for the band's name?

A. His grandmother
B. His sister
C. His housemate
D. His favorite teacher

Answer: C. His housemate.

The new band was named "Jane's Addiction" in honor of Farrell's housemate, Jane Bainter, who was their muse and inspiration."My girl-friend and I were sitting in the car..." Farrell recalled, "and we started to think about band names. She threw in Jane's Heroin Experience. I thought it wasn't vague enough. If you want to invite people in, you don't want to put heroin on your door."

10. Released on their 1991 self-titled album, the lyrics of Metallica's quasi-somnolent hit "Enter Sandman" mention which fairy tale character?

A. Snow White

B. Cinderella

C. Sleeping Beauty

D. Rapunzel

Answer: A. Snow White

In the Spring of 1991, James Hetfield brought the band the lyrics to "Enter Sandman". Originally proposed to be a song about crib death, Hetfield explains "y'know, baby suddenly dies, the sandman killed it." Bob Rock and Lars Ulrich both recall telling Hetfield that this was not the best approach to what they expected to be a huge song and the Metallica frontman reworked "Enter Sandman" to be a more metaphorical song about nightmares instead..

11. The Smashing Pumpkins have undergone many lineup changes over the past 20+ years, but which of these musicians joined the band most recently?

A. Billy Corgan

B. D'arcy Wrtezky

C. Jeff Schroeder

D. Jimmy Chamberlin

Answer: C. Jeff Schroeder

In 2007, Schroeder replaced founding member James Iha as the new rhythm guitarist for The Smashing Pumpkins. While the band has had many lineup changes over the years, in 2010 Jeff Schroeder became the only member of the band still present from the 2007 revival show in Paris. 15 years later, he remains the only 'new' member of the band, following the return of founding members James Iha and Jimmy Chamberlin.

12. Much of the appeal and success of the grunge era can be attributed to the bands collectively referred to as the "Big 4 of Grunge". Which

following band was NOT one of the big 4?

A. Foo Fighters
B. Nirvana
C. Pearl Jam
D. Alice in Chains

Answer: A. Foo Fighters.

The 4th group in the collective "Big 4 Of Grunge" is Soundgarden, the Chris Cornell fronted group from Seattle. In 1994, Nirvana was dissolved following the suicide of Kurt Cobain and drummer Dave Grohl went on to begin the band originally solo-project Foo Fighters. After releasing the self-titled *Foo Fighters* album, Grohl recruited bassist Nate Mendel and drummer William Goldsmith, both formerly of Sunny Day Real Estate, as well as Nirvana's touring guitarist Pat Smear.

13. The cover art for the Red Hot Chili Peppers' "One Hot Minute" album features which mythical creature playing a mandolin while sitting atop a piano?

A. A mermaid
B. A leprechaun
C. A pixie
D. A troll

Answer: C. A pixie

In 1995 the Red Hot Chili Peppers released "One Hot Minute" following their first taste of commercial success with the album "Blood Sugar Sex Magik" in 1991. In 1992, between the two albums, renowned guitarist John Frusciante became uncomfortable with the increased publicity the band was receiving and left the group mid-tour - thus "One Hot Minute" features Jane's Addiction's Dave Navarro in place of Frusciante.

14. With songs such as "Tired of Sex", "The Good Life" and "El Scorcho", what was the title of Weezer's second studio album?

A. Pinkerton
B. Blue Album
C. Green Album
D. Make Believe

Answer: A. Pinkerton

The album Pinkerton was released in 1996, two years after the mainstream success of *Weezer* (commonly referred to as the 'Blue Album'). Weezer opted to produce this album themselves with the intent of better capturing their live sound, leading to a much more gritty and abrasive album that received middling reviews from critics upon release. Years later, the album has ascended from cult-classic to being universally panned as a success by some of the same publications that lambasted it a decade prior.

15. In the lyrics of "Creep" by Radiohead, the subject of the song is described as looking like what type of celestial being?

A. God
B. Angel
C. Goddess
D. Cherub

Answer: B. Angel

The lyrics are as follows:

> "When you were here before
> Couldn't look you in the eye
> You're just like an angel
> Your skin makes me cry"

Radiohead debuted their first single in September of 1992 with "Creep." Guitarist Johnny Greenwood recalls the song being inspired by a girl that Thom Yorke "followed around" at Exeter University who later showed up unexpectedly to a show by the band. It wasn't until 1993 when the song was re-released on the debut album *Pablo Honey* that it began to gain radio play, though Radiohead has since tried to separate themselves from the commercial success of the song in favor of more eclectic recordings.

16. Outside his body of work with Soundgarden, Chris Cornell also wrote and performed "Hunger Strike" with which group?

 A. Pigface
 B. Temple of the Dog
 C. Voodoocult
 D. Mad Season

Answer: B. Temple of the Dog

In 1990, Temple of the Dog was formed in Seattle as a 'supergroup' composed of Stone Gossard on rhythm guitar, Jeff Ament on bass guitar (both formerly in Mother Love Bone and later Pearl Jam), Mike McCready (later Pearl Jam) on lead guitar, and Matt Cameron (Soundgarden and Pearl Jam) on drums. Pearl Jam frontman Eddie Vedder also appeared on their only album, 1991's self-titled *Temple Of The Dog* - which went on to be certified as platinum by the RIAA.

17. Jack Endino is more widely known as a producer for the Sub Pop label, but which band did he play guitar for from 1985-1992?

 A. Gruntruck
 B. Mother Love Bone
 C. Green River
 D. Skin Yard

Answer: D. Skin Yard

In 1985 Jack Endino formed the band Skin Yard with Matt Cameron, who would leave the band in 1986 to become the drummer for Chris Cornell's Soundgarden. Prior to his departure, Skin Yard contributed two songs to the 1986 *Deep Six* compilation - an album featuring the work of six Seattle groups, Skin Yard, The Melvins, The U-Men, Soundgarden, Malfunkshun, and Green River. While the album wasn't a commercial success, it is now looked back on as a seminal piece of Seattle Grunge history.

18. Mentioning Jesus six times, the song "Possum Kingdom" was a 1995 hit for which band?

 A. Toadies
 B. Everclear
 C. Candlebox
 D. Bush

Answer: A. Toadies

In 1989, Toadies were formed in Fort Worth, Texas. After releasing several self-produced cassettes as well as the EP *Pleather*, Toadies signed to Interscope Records and released their debut full-length *Rubberneck*. After more than a year of touring, ready to accept that their Interscope debut wasn't a guaranteed path to success, *Rubberneck* finally started to get radio play with the song "Possum Kingdom." Toadies went back to the studio in 1997 to record their follow-up, only to have it denied release by Interscope Records, remaining that way until 2010 when the band chose to release their album *Feeler* with Kirkland Records instead.

19. With a film clip featuring footage from the Vietnam War, which Alice in Chains song begins with the line "Ain't found a way to kill me yet"?

A. Them Bones

B. Rooster

C. Sickman

D. God Smack

Answer: B. Rooster

The Alice in Chains song "Rooster" was written by Alice in Chains guitarist and vocalist Jerry Cantrell as an homage to his father Jerry Cantrell Sr. who had served in the Vietnam War. The title of the song comes from Cantrell Sr.'s childhood nickname, 'Rooster', given to him by his great-grandfather, though the title is often misattributed to different Vietnam-era weaponry or armed divisions instead.

20. With lyrics including "When I want something, I don't want to pay for it", "Been Caught Stealing" came from which Jane's Addiction album?

A. Nothing's Shocking

B. Kettle Whistle

C. Ritual de lo Habitual

D. Live and Rare

Answer: C. Ritual de lo Habitual

1990's *Ritual de lo Habitual* is the second studio album from Jane's Addiction, and their final album before their 1991 break-up (though the band has since reunited and broken up again many times since). *Ritual de lo Habitual* was released to critical acclaim, much like 1988's debut studio album *Nothing's Shocking* preceding it. "Been Caught Stealing" was the band's biggest hit, spending four weeks atop the US Modern Rock Chart while the accompanying music video went on to win Best Alternative Video in the 1991 VMA's.

ANSWERS AND FUN FACTS: 21 - 40

21. Reaching #37 on the Billboard Modern Rock Chart, "Sweet 69" by Babes in Toyland is noted for the liberal use of which percussion instrument?

A. Cow bell
B. Tambourine
C. Triangle
D. Claves

Answer: A. Cow bell

Released on 1995 album *Nemesisters,* "Sweet 69" was the first Babes in Toyland single to reach mainstream US audiences, peaking at 37th on the US Billboard Hot Modern Rock Tracks. Unfortunately, the album was not nearly as well-received as the previous *Fontanelle* in 1992, and was the final album Babes in Toyland would release breaking up after losing their record label in 1996. After a series of lineup changes and short-term tours, the band called it quits in 2002. While they've since reunited in 2014, it was short-lived with a series of controversies leading to the band to finally split for good in 2015.

22. The bassitar *(this is not a typo – pronounced "base-it-tar", rhymes with guitar)* and the guitbass *(not a typo – pronounced "git-base)* which were regular guitars with special modifications and fewer strings - are synonymous with the music of which band?

 A. Queens of the Stone Age
 B. Smashmouth
 C. Offspring
 D. Presidents of the United States of America

Answer: D. Presidents of the United States of America

The Presidents of the United States of America are renowned for their self-titled album, re-released by Columbia Records in 1995 containing the singles "Lump", "Peaches", and "Kitty" which has been certified as triple platinum by the RIAA since its release. All of these were recorded with the unique instruments, the 'bassitar' and 'guitbass'. The bassitar has two heavy-gauge bass strings used for bass parts of songs, while the guitbass has three regular guitar strings and three heavy-gauge bass strings in place of regular guitar strings.

23. Released in 1999 on the album "A Place in the Sun", "My Own Worst Enemy" was a song by which band?

 A. Lit
 B. Tonic
 C. Blur
 D. Fuel

Answer: A. Lit

My Own Worst Enemy" is, according to Lit guitarist Jeremy Popoff, "the result of waking up and realizing you screwed up the night before" while Vocalist A. Jay Popoff remembers the song as "the combination of many, many incidents". While Lit members may be hesitant to remember these moments of self sabotage, they led to a

song that reached the number one spot of the US Alternative Songs chart in 1998 and 18th on the US Mainstream Rock charts the same year.

24. Nirvana's "Smells Like Teen Spirit" is an anthem of the grunge era, but where did the title for the song come from?

A. It was written on Kurt Cobina's wall by his girlfriend
B. Dave Grohl saw it written on a toilet door
C. Kirst Novacelic heard it on TV
D. Kurt Cobain saw it in a magazine

Answer: A. It was written on Kurt Cobain's wall by his girlfriend.

At the time "Smells Like Teen Spirit" was written, Kurt Cobain was dating Kathleen Hanna from Bikini Kill. At one point, Hanna wrote "Kurt smells like Teen Spirit" on the wall of his hotel room, referencing the name of the deodorant she was wearing. Cobain interpreted the song as a catchphrase, and turned it into the title of Nirvana's best-known song.

25. Soundgarden formed in 1984, but which of these guitarists was the only one to appear in every iteration of the band?

A. Matt Cameron
B. Kim Thayil
C. Jason Everman
D. Ben Shepherd

Answer: B. Kim Thayil

Chris Cornell, Hiro Yamamata, and Kim Thayli formed Soundgarden in 1984. Thayli remained with the band until Cornell's death in 2017, and the dissolution of the band in 2018. Thayli has received two

Grammys for his work in Soundgarden, and earned a place in both The Rolling Stone and SPIN's '100 greatest guitarists of all time' lists - 100th in the former, and 67th in the latter.

26. The first Top 40 US hit for the Smashing Pumpkins was a song about what object with butterfly wings?

A. Missile
B. Bazooka
C. Bullet
D. Grenade

Answer: C. Bullet

"Bullet with Butterfly Wings" was The Smashing Pumpkins first top 40 US hit, peaking at #22 on the Billboard Hot 100. The song won the Grammy Award for Best Hard Rock Performance in 1997, and was the first music video released from the album "Melon Collie and the Infinite Sadness". When asked why the band chose Bullet for the first video, Corgan responded "the record company did a survey of K-Mart shoppers between 30 and 40 and this is the song they came up with".

27. With a title very appropriate for the group who recorded it, "Transnational Speedway League" was the 1993 debut album for what band?

A. Clutch
B. Brake
C. Slide
D. Crash

Answer: A. Clutch

"Transnational Speedway League: Anthems, Anecdotes and Undeniable Truths" was released in 1993 to positive reception from music crit-

ics, though it would be the next Clutch albums "Clutch" (1995), "The Elephant Riders" (1998), and 2001's "Pure Rock Fury" that marked a steady climb on the Billboard charts for the band. Clutch has released 12 studio albums over their tenure, with their four most recent albums released on their own Weathermaker Music label.

28. With guest performances by Slash, Nikki Sixx and Ozzy Osbourne, which Alice Cooper album was recorded in the 1990s?

 A. Trash
 B. Raise Your Fist And Yell
 C. Hey Stoopid
 D. Constrictor

Answer: C. Hey Stoopid

Hey Stoopid is the 12th album released by Alice Cooper, featuring many big name collaborators and guest performers including Lance Bulen, Slash, Ozzy Osbourne, Vinnie Moore, Joe Satriani, Steve Vai, Nikki Sixx and Mick Mars. Despite the amount of star-power on the album, it received middling reviews while the single "Hey Stoopid" reached 78th on the Billboard Hot 100.

29. Marilyn Manson's "Mechanical Animals", Hole's "Celebrity Skin" and Pearl Jam's "Yield" were all albums released in what year of the 1990s?

 A. 1999
 B. 1998
 C. 1997
 D. 1996

Answer: B. 1998

1998 was a massive year for rock music releases. Some bands and performers (notably Marilyn Manson on the "Mechanical Animals" album) became more diverse and experimental, while others (such as Pearl Jam) went back to their roots. "Celebrity Skin" went on to become Hole's most commercially successful album, and featured contributions from several musicians from outside the band.

30. Released by Columbia Records in 1990, Alice in Chains' debut studio album shares its name with which cosmetic surgery procedure?

 A. Liposuction
 B. Rhinoplasty
 C. Facelift
 D. Dermabrasion

Answer: C. Facelift

Alice in Chains released their first studio album "Facelift"in 1990. It went on to become the first grunge album to be certified gold on September 11th, 1991. "Man In The Box" from the album was nominated for a Grammy Award for Best Hard Rock Performance with Vocals in 1992. The album peaked at number 42 on the Billboard 200 chart and has since gone on to be certified double platinum.

31. Alongside Tim Commerford and Zack de la Rocha, Tom Morella formed Rage Against The Machine after previously playing with which band?

 A. Audioslave
 B. Run the Jewels
 C. Lock Up
 D. Deftones

Answer: C. Lock Up

Lock Up was formed four years before Rage Against the Machine in Los Angeles, California in 1987. After releasing one album, "Something Bitchin' This Way Comes" on Geffen Records in 1989, the band dissolved in 1990, making way for Tim Commerford, Zach de la Rocha, Tom Morello, and Brad Wilk to jam together and officially become Rage Against The Machine a year later in 1991.

32. November 1991 saw the release of U2's "Achtung Baby", "Loveless" by My Bloody Valentine and which of these albums?

 A. "Copper Blue" by Sugar
 B. "Dirty" by Sonic Youth
 C. "Lull" by the Smashing Pumpkins
 D. "Wish" by The Cure

Answer: C. "Lull" by the Smashing Pumpkins

After releasing the "Lull" EP in November 1991, The Smashing Pumpkins signed to Virgin Records, a much larger imprint affiliated with Caroline Records whom they had released "Lull" with. The Smashing Pumpkins opened for bands like The Red Hot Chili Peppers, Jane's Addiction, and Guns N' Roses while promoting the EP, before they headed back into the studio in 1992 to release .

33. With songs such as "Low" and Endgame", which R.E.M. album won the band's first Grammy for 'Best Alternative Music Album'?

 A. "Monster"
 B. "New Adventures in Hi-Fi"
 C. "Up"
 D. "Out of Time"

Answer: D. "Out of Time"

Out Of Time was an absolutely huge album for R.E.M., spending 109 weeks on the U.S. Billboard charts - including two weeks in first, selling more than 18 million copies, and winning three Grammy awards in 1992: one for Best Alternative Music Album, and two for the single "Losing My Religion."

34. First released as a bonus track on their "Angel Dust" album, Faith No More's "Easy" was a cover originally recorded by which band?

 A. Earth, Wind and Fire
 B. The Temptations
 C. The Jackson 5
 D. The Commodores

Answer: D. The Commodores

Faith No More's album "Angel Dust" was released to positive critical reception in 1992. The album charted one single spot higher than their previous effort "The Real Thing", although it sold less copies than the former album in the US. "Angel Dust" did however, outsell "The Real Thing" in many other countries, becoming more popular than their prior album in the Netherlands, France, Russia, and the United Kingdom.

35. With the song noted for its switches between speaking and singing, which following name is not mentioned in "Pepper" by Butthole Surfers?

 A. Marky
 B. Larry
 C. Bobby
 D. Tommy

Answer: B. Larry

While Marky, Sharon and Cherese found themselves in a love triangle, Mikey had a facial scar, Bobby was, unfortunately, a racist, and Tommy played piano, Larry is absent from Butthole Surfer's 1996 hit "Pepper." A common rumor is that this song was either an homage or a rip-off of Beck - his influence on the track has never been confirmed by the band.

36. Releasing their self-titled debut album in 1991, the band Pennywise took their name from a character invented by which author?

 A. Clive Barker
 B. Dean Koontz
 C. Stephen King
 D. James Patterson

Answer: C. Stephen King

In 1998 the band Pennywise was formed in Hermosa Beach, California, taking their inspiration from the Stephen King novel "It". Pennywise has since sold millions of albums at a breakneck pace, averaging an album every other year for 24 years as well as two EPs, a live album and one DVD.

37. Also known as The Thunder God for his drumming abilities, how did Def Leppard's Rick Allen lose his left arm?

 A. Cancer
 B. A car accident
 C. A farming accident
 D. Sepsis

Answer: B. A car accident

Def Leppard had already released three studio albums, with their most recent "Pyromania", charting at number 2 on the Billboard Hot 200 by

1984 when Rick Allen was involved in a gruesome car accident that severed his left arm. Allen took a brief hiatus from touring, but soon returned with the help of an electronic kit that allowed him to play sounds his left arm previously did with the use of additional pedals, and he's remained with the band to this day.

38. First covered by Pearl Jam on a charity album in 1999, "Last Kiss" topped the singles chart in which country for 7 weeks?

A. New Zealand
B. Australia
C. Ireland
D. Sweden

Answer: B. Australia

By 1997, Pearl Jam were mythical figures in Australia having cemented their status during their first tour down under in 1995. A tour in which they were playing three of their best known-to-date albums for the first time in the country, selling out shows, and fighting with security in the defense of Australian fans, Pearl Jam even brought out Dave Grohl during the climax of one Melbourne show. It's no wonder that four years later, Australian fans were so keen to listen to their newest single.

39. As well as being the original vocalist in the Gin Blossoms, Jesse Valenzuela played which instrument in the band?

A. Drums
B. Rhythm guitar
C. Keyboard
D. Bass guitar

Answer: B. Rhythm guitar

Jesse Valenzuela was originally the vocalist for Gin Blossoms in 1987 when the band was formed, but come 1988 he switched roles with the bands new guitarist Robin Wilson to play rhythm guitar instead. Valenzuela remained with the band until 1997 when they broke up, and reunited with the band in 2002 when they got back together for a reunion tour.

40. Which track from Green Day's 1994 "Dookie" album is a hidden track, performed by Tre Cool?

A. In The End
B. Coming Clean
C. Sassafras Roots
D. All By Myself

Answer: D. All By Myself

All By Myself is a solo track by Tre Cool, hidden after 1 minute and 17 seconds of silence at the end of F.O.D. in which Tre Cool plays guitar on a stripped-down song and sings about masturbation in an amusing voice. Since the digital release of "Dookie", "All By Myself" has been visible on track-lists and is no longer quite the 'secret track' it used to be.

ANSWERS AND FUN FACTS: 41 - 60

41. The 1991 compilation album "The Grunge Years" featured "Tomorrow" by Fluid, "Saddle Tramp" by Dickless and which song by Mudhoney?

 A. Come to Mind
 B. You Got It
 C. Here Comes Sickness
 D. When Tomorrow Hits

Answer: A. Come to Mind

The Grunge Years was a compilation album released by Sub Pop Records in 1991. Released as a limited pressing, there were 500,000 copies of the album pressed for sale. *The Grunge Years* features songs by Nirvana., Babes in Toyland, and Mudhoney, as well as 9 other bands of the era.

42. The second single from Weezer's self-titled debut album shares its name with which legend of music?

A. Elvis Presley

B. Chubby Checker

C. Frank Sinatra

D. Buddy Holly

Answer: D. Buddy Holly

Thanks to the power of songs like "Buddy Holly", "Undone - The Sweater Song", "In The Garage" and "My Name Is Jonas", Weezer cemented themselves in Rock and Roll history books forever. Commonly referred to as "The Blue Album", Weezer's first release has made its way onto plenty of 'Best-of' lists, including Rolling Stone's 500 Best Albums of All Time at number 294.

43. Which song from Nirvana's third studio album "In Utero" was allegedly about an intimate part of Courtney Love's anatomy?

A. Dumb

B. Milk It

C. Heart-shaped Box

D. Very Ape

Answer: C. Heart-shaped Box

"Heart-Shaped Box" is a song that has always had a bit of mystery behind it's lyrics, with Kurt Cobain telling biographer Michael Azerrad that the song was inspired by documentaries about children with cancer. However, in 2012, Courtney love went to Twitter to tell fans that she had contributed to the lyrics of the song and that they were about her body, though those tweets were deleted shortly after.

44. All of the following bands played an iconic role in rock music, but which band was formed most recently?

A. Blur

B. White Zombie
C. Korn
D. Alice in Chains

Answer: C. Korn

While Blur, White Zombie, and Alice and Chains were formed in the latter half 1980's, it wouldn't be until 1993 that Korn was formed. Notable for bringing 'nu metal' to a mainstream audience, Korn has sold more than 40 million records worldwide, twelve of their releases have peaked in the top 10 of the Billboard 200, and seven of their releases have been certified platinum by the RIAA.

45. Despite sounding more like a macabre take on a Queen hit, "Somebody to Shove" was recorded by which band in 1992?

A. Goo Goo Dolls
B. Collective Soul
C. Spin Doctors
D. Soul Asylum

Answer: D. Soul Asylum

"Somebody To Shove" was the first single from Soul Asylum's *Grave Dancers Union* (1992) which reached number one on the Modern Rock Tracks chart and number nine on the Mainstream Rock Tracks chart in the US. Notably, the music video for the song was directed by prolific American film director Zack Snyder.

46. As well as being a member of the Smashing Pumpkins, which musician is well-known for his role in the governing and promotion of wrestling?

A. Mike Byrne
B. Billy Corgan

C. James Iha

D. Jeff Schroeder

Answer: B. Billy Corgan

Billy Corgan has been involved with professional wrestling since 2011 when he formed Resistance Pro wrestling in Chicago. Since then, Corgan has worked with AMC to develop a show about his involvement in wrestling, has worked as the Senior Producer of Creative and Talent Development for Total Nonstop Action Wrestling, and has purchased the National Wrestling Alliance in 2017.

47. The 'Velvet' supergroup featuring members such as Slash, Duff McKagan and Scott Weiland also had what weapon in the band's name?

A. Shotgun

B. Pistol

C. Revolver

D. Handgun

Answer: C. Revolver

Velvet Revolver was formed in 2002, consisting of Guns N' Roses members Duff McKagan, Slash, and Matt Sorum, alongside Dave Kushner of Wasted Youth and Scott Weiland from Stone Temple Pilots. The band was active for six years until 2008 when Scott Weiland unexpectedly departed to rejoin Stone Temple Pilots, leaving the other Velvet Revolver members trying to find a new vocalist and end their contract with RCA records.

48. Which following word completes the line "Watching, waiting, (blank)" from Blink 18's hit "All the Small Things"?

A. Intimidating

B. Discriminating

C. Commiserating

D. Accelerating

Answer: C. Commiserating

The lyric is as follows:

> *"Always I know*
> *You'll be at my show*
> *Watching, waiting*
> *Commiserating"*

All The Small Things was the second single off the band's third album *Enema of the State* in 1999. The band members recall recording the song as they felt they needed a song to ship to radio stations that was "really catchy and basic" and it worked - remaining their most popular single to this date, and their only song to break into the Top 40.

49. Best known as a vocalist for Evanescence, rock goddess Amy Lee is also notable for playing which instrument?

A. Flute

B. Violin

C. Ukulele

D. Harp

Answer: D. Harp

Grammy award-winning vocalist Amy Lee is not only known for her phenomenal mezzo-soprano voice, but also for her skill with both the harp and the piano as well. Lee has performed as the frontwoman for rock band Evanescence, as well as individually as a composer for film soundtracks as well in recent years. She was awarded the Best Film Score by the Moondance International Film Festival in 2015 for her work on *Indigo Grey: The Passage.*

50. Iconic grunge song "Smells Like Teen Spirit" was stripped back and covered by which songstress on her "Little Earthquakes" album?

 A. Fiona Apple
 B. Kate Bush
 C. Tori Amos
 D. PJ Harvey

Answer: C. Tori Amos

Little Earthquakes is the debut album by Tori Amos, featuring singles such as "Silent All Thes Years", "China", "Winter", and "Crucify". The album was popular with music critics, and peaked at number 14 in the UK where it was released. Meanwhile, in the US the album reached the Top 60 of the Billboard 200. The Deluxe Edition release in 1991 included Amos' own rendition of Nirvana's "Smells Like Teen Spirit."

51. The lead singer of The Wallflowers is also the fourth child of which folk music legend?

 A. Bob Dylan
 B. Van Morrison
 C. Neil Young
 D. Jackson Browne

Answer: A. Bob Dylan

Jakob Dylan is the frontman of The Wallflowers, his band that was formed in 1989. While many members have come and gone in 32 years, Dylan has remained the steadfast presence in the band. The Wallflowers has won two Grammy Awards: Best Rock Performance by a Duo or Group with Vocal and Best Rock Song for "One Headlight" in 1998.

52. Ben Folds Five's biggest commercial success was "Brick", but what was their first rado single released in 1995?

A. Philosophy
B. Sports and Wine
C. Underground
D. Boxing

Answer: C. Underground

Ben Fold's Five's first radio single "Underground" was released in 1995 on *The Ben Folds Five.* The song is about geeks and social outcasts looking for solace in numbers in underground music and art scenes. It peaked at #37 on the UK Singles Chart, which is unremarkable compared to 17th on the US Top 40 Mainstream chart for "Brick" a year later.

53. In their 1996 Grammy-nominated song, how many "Peaches" did the Presidents of the United States of America sing about?

A. Thousands
B. Heaps
C. Hundreds
D. Millions

Answer: D. Millions

The lyrics are as follows:

> *Millions of peaches, peaches for me*
> *Millions of peaches, peaches for free*

"Peaches" was the 3rd single from the Presidents of the United States of America's self-titled album. The inspiration for the song came when the band's lead singer, Chris Ballew, overheard a homeless man

muttering a phrase that became one of the song's refrains - "I'm moving to the country, gonna eat a lot of peaches".

54. Rock legend Dave Grohl played drums for Nirvana, fronted the Foo Fighters and also founded which following supergroup?

 A. Them Crooked Vultures
 B. Atoms For Peace
 C. Tinted Windows
 D. Dead By Sunrise

Answer: A. Them Crooked Vultures

Them Crooked Vultures was founded in 2009 with Josh Homme (of Queens of the Stone Age) on lead vocals and guitar, John Paul Jones (of Led Zeppelin) on bass and keyboards, and Dave Grohl on drums and vocals. The group won the Grammy Award for Best Hard Rock Performance for "New Fang" in 2011.

55. Recorded on the band's third and final album was Nirvana's song about what which following substance?

 A. Pennyroyal tea
 B. Rosewater
 C. St John's Wort
 D. Witch-hazel

Answer: A. Pennyroyal tea

Intended to be the third single from *In Utero* in April 1994, the single was recalled after Kurt Cobain's tragic suicide in the same month. Some skeptics believe that the title of one of the b-sides, "I Hate Myself and Want To Die" contributed to the reasoning for pulling the single, while others believe that the single would have gone unreleased

regardless so as to not seem opportunistic for sales in the wake of Cobain's passing.

56. Fronted by Wes Scantlin and having a debut album entitled "Abrasive", which following band formed in Kansas City in September 1991?

A. Staind
B. Puddle of Mudd
C. Seether
D. Theory of a Deadman

Answer: B. Puddle of Mudd

Puddle of Mudd was formed in 1991 in Sugar Land, Texas. The band has sold over five million copies of their debut album *Come Clean*. Puddle of Mudd has since become known for lip-syncing controversies (three of them), for deleting their Facebook after being criticized for lip-syncing only to have another band take the page's name to promote themselves, and for failing to appear for festival shows.

57. The cover of Pulp's "Different Class" album featured a wedding congregation, including bridesmaids wearing what colored dresses?

A. Red
B. Blue
C. Pink
D. Yellow

Answer: D. Yellow

"Different Class" is the fifth studio album by English band Pulp. The album was wildly successful, winning the 1996 Mercury Music Prize, becoming certified platinum four times over, and being ranked as NME's 6th best album on their '500 Greatest Albums of All Time' list.

58. The lyrics of which Alice in Chains song featured the refrain "One who doesn't care, is one who shouldn't be"?

A. Junkhead
B. No Excuses
C. Dirt
D. Rotten Apple

Answer: C. Dirt

The song "Dirt" comes from the 1992 album of the same name by Alice In Chains. "Dirt" was the last album recorded with all of the band's original members, prior to bassist Mike Starr being fired from the band in 1993. "Dirt" is the band's highest-selling album to date, having moved five million copies worldwide and becoming certified 4x platinum by the RIAA.

59. Footage from iconic TV show "Happy Days" was used in a 1994 video clip by which band?

A. Green Day
B. Presidents of the United States of America
C. Weezer
D. Offspring

Answer: C. Weezer

The music video for "Buddy Holly" by Weezer was shot at Charlie Chaplin Studies in Los Angeles on the set of the 1970s show "Happy Days". The video also contains a cameo from Happy Days cast member Al Molinara, who introduces the band in the video. The song is quite the homage to yesteryear, making mention of not just the song's namesake, but also Mary Tyler Moore.

60. With the last line "She's my one and only", Which following Smashing Pumpkins song came from "Mellon Collie and the Infinite Sadness"?

 A. Zero
 B. Quiet
 C. Soma
 D. Rocket

Answer: A. Zero

"Zero" was the third single from *Mellon Collie and the Infinite Sadness* by The Smashing Pumpkins. The song is notable for having six rhythm guitars as well as two twelve string acoustic guitars on the track. Commerically, the song was a huge hit reaching number one in Spain, three in New Zealand, and number 15 on the US Mainstream Chart.

ANSWERS AND FUN FACTS: 61 - 80

61. Fronted by the infamously quarrelling Gallagher brothers, Oasis were formed in 1991 in which English city?

A. Birmingham
B. Manchester
C. Liverpool
D. Sheffield

Answer: B. Manchester

Oasis were formed in Manchester in 1991 by Liam and Noel Gallagher alongside Paul Arthurs, Paul McGuigan and Tony McCarroll. Their second album "(What's the Story) Morning Glory", released in 1995 is one of the best selling albums of all time, containing singles like "Wonderwall", "Don't Look Back In Anger", and "Wonderwall", leading the album to reach number four on the US Billboard 200 charts. The album has since gone on to be certified 4x platinum.

62. First formed in London in 1988 and helping establish the Britpop genre, Blur released which of these albums first?

A. Modern Life Is Rubbish

B. Leisure

C. The Great Escape

D. Parklife

Answer: B. Leisure

Blur's debut album "Leisure" was released in 1991 to rave reviews from critics, though in retrospect Blur frontman (and later Gorillaz creator) Damon Albarn had much more critical things to say about the work describing it as "awful" and being one of the two "bad records" he has made in his career. Albarn further expanded on the album's recording in 2014, explaining that "it wasn't a particularly happy experience" and suggested the band were too keen to please the record label by capitalizing on a sound that was popular at the time.

63. In 1991, which band collaborated with metal outfit Anthrax to remake the hit song "Bring the Noise"?

A. Public Enemy

B. Run-D.M.C.

C. Beastie Boys

D. N.W.A

Answer: A. Public Enemy

Four years after the release of the original song "Bring the Noise" by Public Enemy, Anthrax reached out to the group about a collaboration to remake the song together." While neither version had huge chart success, the Anthrax remake was featured in 7 different Tony Hawk's Skateboarding and WWE video game titles.

64. A side project of several 1990's grunge bands, the band Mad Season did not include which of these musicians?

A. Layne Staley
B. Eddie Vedder
C. Mike McCready
D. Barrett Martin

Answer: B. Eddie Vedder

While many of his other grunge-era peers were keen to start 'super-groups' and record together, Eddie Vedder has spent most of his career either recording with Pearl Jam, working on solo projects, or occasionally appearing on songs of other groups (such as Temple of The Dog) but he has never joined any of these groups as a full time member..

65. Which following reptile is mentioned in "Black Hole Sun", the 3rd single from Soundgarden's "Superunknown" album?

A. Snake
B. Lizard
C. Turtle
D. Alligator

Answer: A. Snake

The band itself is named after a sculpture in Seattle called "Soundgarden". Longtime speculation is that the song "Black Hole Sun" derived its name from another Seattle sculpture called "Black Sun" by the artist Isamu Noguchi. (The piece is located in Volunteer Park on Capitol Hill.)

66. Prior to releasing their "Uncle Anesthesia" album in 1991, the Screaming Trees signed with which major record label?

A. Impact Records
B. Redbird Records
C. Epic Records

D. Virgin Records

Answer: C. Epic Records

Screaming Trees were known as one of the pioneers of grunge along with the Melvins, Mudhoney, U-Men, Skin Yard, Soundgarden, Green River, and Malfunkshun, all from Seattle or the surrounding area. Formed in 1985, the band spent 4 years of recording and touring before being picked up by Epic Records in 1990.

67. Founded in Seattle in 1986, which following record label became synonymous with early 90's grunge music?

 A. Crammed Discs
 B. Autumn Records
 C. Sub Pop
 D. Virus Music

Answer: C. Sub Pop

Sub Pop Records was founded in 1986 by Bruce Pavitt and Jonathon Poneman. Sub Pop rose to fame in the early 1990s for signing Seattle bands like Nirvana, Soundgarden, and Mudhoney. They've since become one of the preeminent Indie labels, with their roster including Fleet Foxes, The Postal Service, Beach House, Blitzen Trapper, The Shins, and many more.

68. Also known by the first names Foo and Ted, Matt Cameron famously played drums for Soundgarden and which other band?

 A. Smashing Pumpkins
 B. Alice in Chains
 C. Pearl Jam
 D. Weezer

Answer: C. Pearl Jam

Matt Cameron has played a crucial role in the history of grunge, playing drums in Skin Yard from 1983-1986 before being a founding member of Soundgarden in 1986 when Skin Yard broke up. In 1998, he joined Pearl Jam. Cameron has also played with supergroup Temple of The Dog, as well as drumming on tracks for The Smashing Pumpkins.

69. Nirvana's Kurt Cobain and Alice in Chains' Layne Staley both died on which date, 8 years apart?

 A. November 6
 B. June 4
 C. April 5
 D. February 7

Answer: C. April 5

Kurt Cobain died of a self-inflicted gunshot wound on April 5th, 1994, shaking the grunge scene and leading to the dissolution of hit group Nirvana. Eight years later, Layne Staley was found dead in his home on the same date of an accidental drug overdose from a mixture of cocaine and heroin.

70. First staged in 1991, which following music festival is noted for giving stage time to many grunge and alternative rock bands?

 A. Lollapalooza
 B. Reading Festival
 C. Beale Street
 D. Warped

Answer: A. Lollapalooza

Lollapalooza is an annual music festival held in Grant Park in Chicago, Illinois. The inaugural Lolapalooza was created in 1991 as a farewell tour by Perry Farrell, the singer of Jane's Addiction. Since then, the festival has gone on to expand to both Chile and Argentina dates as well as the Chicago event.

71. Which band, influential in the grunge and alternative metal genres, lost their frontman to a heroin overdose shortly before their first major release?

A. White Zombie
B. Talking Heads
C. Green River
D. Mother Love Bone

Answer: D. Mother Love Bone

Mother Love Bone was a Seattle rock band formed in 1988, only active for two years due to the unfortunate death of frontman Andrew Wood days before the release of the bands debut album *Apple.* Jeff Ament and Stone Gossard would go on to become founding members of Pearl Jam after the band dissolved.

72. Born Mark Thomas McLaughlin in 1962, Mark Arm sang with which other band prior to fronting rock band Mudhoney?

A. Malfunkshun
B. The U-Men
C. Green River
D. The Melvins

Answer: C. Green River

Mark Arm was the frontman for Green River, one of the first grunge bands from the Seattle area. Green River were one of the bands on the

Deep Six compilation, a seminal piece of grunge history consisting of six bands that were seminal bands to the growth of the Seattle sound.

73. With songs such as "Reach Down" and "Say Hello 2 Heaven", Temple of the Dog was conceived as a tribute to which musician?

 A. Andrew Wood
 B. Mike Starr
 C. Kurt Cobain
 D. Scott Weiland

Answer: A. Andrew Wood

Temple Of The Dog was conceived as a tribute to Andrew Wood, the Mother Love Bone vocalist who died an untimely death of drug overdose days before the release of "Apple", the band's debut album. While Mother Love Bone never had a chance to see the stardom of some of their contemporaries, other members went on to success in other grunge outfits such as Pearl Jam before the founding of Temple of The Dog.

74. One of the most accomplished music producers of his time, Rob Cavallo is widely known for his work with which of these bands?

 A. Fall Out Boy
 B. Green Day
 C. Linkin Park
 D. The Offspring

Answer: B. Green Day

Rob Cavallo has produced many platinum albums in his tenure, including Green Day's Dookie, Insomniac, Nimrod, American Idiot, and Bullet in a Bible. Cavallo also has platinum albums under his belt

with Goo Goo Dolls, My Chemical Romance, Dave Matthews Band, Phil Collins, Kid Rock, and Shinedown.

75. Prior to forming Sweet 75 and Eyes Adrift, Krist Novoselic was a bassist and founding member of which band?

A. Metallica
B. Foo Fighters
C. Nirvana
D. Pixies

Answer: C. Nirvana

Krist Novaselic and Kurt Cobain formed Nirvana in Aberdeen, Washington in 1987. After shuffling through drummers for years, the most notable being Chad Channing, Dave Grohl joined the band in 1990. The band was only together with all three members for four years, before the suicide of Kurt Cobain and the dissolution of the band.

76. The final single off the album "Transistor", "Beautiful Disaster" was a song by a band with which numerical name?

A. 311
B. 269
C. 194
D. 457

Answer: A. 311

Transistor was the fourth album by 311, released in August of 1997. The album was considered overlong and self indulgent by music critics at the time, clocking in at 68 minutes and 28 tracks long. The album has been considered more favorably in retrospect, however, and has been certified as platinum by the RIAA.

77. Widely acknowledged as one of the greatest guitarists in music history, Slash from Guns N Roses started which side project in 1994?

 A. Slash's Torture Chamber
 B. Slash's Snakepit
 C. Slash's Hellpit
 D. Slash's House of Pain

Answer: B. Slash's Snakepit

Slash's Snakepit was formed in 1994, consisting of Slash, Matt Sorum and Gilby Clarke from Guns n' Roses, as well as Mike Inez of Alice in Chains and Eric Dover of Jellyfish. The band was active for a total of three years between stints from 1994-1995 and between 1998-2002.

78. With music written by John Frusciante and Flea, "Give It Away" by Red Hot Chili Peppers was the lead song from which album?

 A. Mother's Milk
 B. One Hot Minute
 C. Blood Sugar Sex Magick
 D. Californication

Answer: C. Blood Sugar Sex Magick

Blood Sugar Sex Magick was the fifth studio album from the Red Hot Chili Peppers, peaking at number three on the US Billboard 200. Hit singles "Under The Bridge", "Give it Away", "Suck My Kiss", "Breaking The Girl" and "If You Have to Ask" carried the album to worldwide fame. This newfound attention led to Frusciante leaving the band due to his discomfort with the spotlight in 1992, to return later in 1998.

79. Released in 1992 under the Interscope Records Label, the first EP by Nine Inch Nails had what following title?

A. The Fragile

B. Broken

C. With Teeth

D. Pretty Hate Machine

Answer: B. Broken

Nine Inch Nails first EP "Broken" was released on September 22, 1992. The album received mixed reviews from critics, but eventually reached number 7 on the Billboard Hot 200, and went on to be certified platinum by the RIAA. After the success of their previous album "Pretty Hate Machine" in 1989, "Broken" served as a middle finger to the label TVT which Reznor resented for constricting his creative control with Nine Inch Nails.

80. The cover of Soundgarden's "Badmotorfinger" album features the album name written in white lettering inside which geometric shape?

A. Triangle

B. Square

C. Circle

D. Star

Answer: A. Triangle

Badmotorfinger is the third album released by Soundgarden on October 8, 1991. It became the band's highest charting release, charting at 39th on the Billboard 200 thanks to the popularity of the Seattle grunge scene of the time. Badmotorfinger was nominated for a Grammy for Best Metal performance, and was certified platinum in 1996.

ANSWERS AND FUN FACTS: 81 - 100

81. Also known as Gamma Ray, the Queens of the Stone Age were founded in 1996 by which following musician?

A. Troy Van Leeuwen
B. Joey Castillo
C. Josh Homme
D. Mark Lanegan

Answer: C. Josh Homme

Josh Homme is the only continuous member of Queens of The Stone Age, formed in 1996. Homme also co-founded Eagles of Death Metal in 1998, playing drums and bass for their studio albums despite predominantly being a guitarist and vocalist for Queens of the Stone Age.

82. Before Nickelback gained widespread success in the rock genre, they performed as a grunge cover band with what name?

A. Local Hero

B. Court Jester

C. Village Idiot

D. Crooked Cousin

Answer: C. Village Idiot

Nickleback was formed in the early 1990s as a cover band called Village Idiot by Mike and Chad Kroeger, with their cousins Brandon Kroeger and Ryan Peake. Chad Kroeger asked his stepfather to give him $4,000 to record their first EP under the name Nickleback in 1996, releasing *Hersher.*

83. Best known for the 1996 song "Counting Blue Cars", rock band Dishwalla hailed from which Californian city?

A. Santa Barbara

B. Long Beach

C. San Jose

D. Modesto

Answer: A. Santa Barbara

Dishwalla was a Santa Barbara rock band best known for their single "Counting Blue Cars" which reached number 4 on the Billboard US Mainstream charts, from the gold certified album *Pet Your Friends* in 1995. Dishwalla never reached this level of fame again, and disbanded in 2005.

84. Named after an alternative school in Minneapolis, the band Marcy Playground is widely regarded as a one-hit wonder for which 1997 song?

A. Love and Rockets

B. Sex and Candy

C. Hot and Sweaty

D. Alive and Kicking

Answer: B. Sex and Candy

Sex and Candy is a that received mixed reviews from critics, however it was a major commercial success that catapulted the band into many one-hit-wonder lists when they failed to replicate that same achievement with their further work. The song peaked at 8th on the US Billboard Hot 100, finishing the year at 28th on the US Billboard Hot 100 Year-end charts.

85. Currently fronted by long-standing member Brett Scallions, Fuel toured extensively with which band in 1998?

A. The Verve

B. Creed

C. The Cure

D. Hootie and the Blowfish

Answer: B. Creed

Fuel was formed in 1989 by Brett Scallions and went on to release a handful of top 10 hits on the Billboard Rock charts, as well as a platinum album in *Sunburn* and a double platinum album in "Something Like Human".. Billboard's Alternative Chart 25th Anniversary: Top 100 Songs placed "Hemorrhage (In My Hands)" as the No. 6 alternative rock song of the past 25 years in 2013.

86. The lyrics "All across the alien nation, where everything isn't meant to be ok" come from which Green Day song?

A. Burnout

B. Hitchin' A Ride

C. American Idiot

D. Reject

Answer: C. American Idiot

American Idiot was released by Green Day in 2004 to critical acclaim. The album has since been certified platinum six times over, won a grammy for Best Rock Album in 2005, and has been adopted into a Broadway musical. Rolling Stone places the album at 225 on their "500 Greatest Albums of all time" list.

87. As heard in the lyrics of 1994's "Lightning Crashes" by Live, what type of being "opens her eyes"?

A. Angel

B. Mermaid

C. Demon

D. Fairy

Answer: A. Angel

The lyrics are as follows:

> *"Lightning crashes*
> *A new mother cries*
> *Her placenta falls to the floor*
> *The angel opens her eyes"*

"Lightning Crashes" reached #12 on 1995's Billboard Hot 100 Airplay chart despite never being released as a single in the US.

88. First released independently in 1997, what title was given to the debut studio album by rock band Creed?

A. Full Circle

B. Weathered

C. Human Clay

D. My Own Prison

Answer: D. My Own Prison

"My Own Prison" was released in 1997 to comparisons of bands like Soundgarden, Pearl Jam, Alice in Chains, Metallica and Tool. The album peaked at 22nd on the Billboard Hot 200, while singles "Torn", "What's This Life for" and "One" received considerable airplay. The album has since been certified platinum six times over, having sold more than 6 million copies in the United States.

89. According to the lyrics of "Self-Esteem" by The Offspring, what time does the singer wait until before he decides to "turn out the light"?

A. 4

B. 3

C. 2

D. 1

Answer: C. 2

The lyrics are as follows:

> *"We make plans to go out at night*
> *I wait 'til 2 then I turn out the light*
> *This rejection's got me so low*
> *If she keeps it up I just might tell her so"*

Self Esteem is the second single from The Offspring's album *Smash*. While the song only achieved middling chart performance in 1995, it was nominated for an MTV Europe Music Award for Best Song and appears on The Offspring's Greatest Hits album.

90. In the title of their third studio album from 1994, rock band Live were "throwing" what type of metal?

A. Bronze
B. Silver
C. Lead
D. Copper

Answer: D. Copper

"Throwing Copper", the 1994 release by Live was produced by Jerry Harrison of The Talking heads and recorded at Pachyderm Recording Studio in Minnesota. "Throwing Copper" is generally regarded as Live's best album and is certainly their most commercially successful, having sold over 8 million copies - becoming certified 8x platinum by the RIAA.

91. Released in 1993, "Everyone Else Is Doing It, So Why Can't We?" is an album by which female-fronted rock band?

A. No Doubt
B. Hole
C. The Cranberries
D. Garbage

Answer: C. The Cranberries

"Everyone Else Is Doing It, So Why Can't We?" Is the debut album and first full length studio album by The Cranberries, released in 1993. On June 24th, 1994, it became the fifth album in rock history to reach number one a year after its release. The album has since gone on to sell more than 5,000,000 copies in the United States.

92. Based on a bout of mononucleosis suffered by the band's lyricist, "Down with Disease" was a song by which following band?

A. Placebo

B. Weezer

C. Phish

D. Korn

Answer: C. Phish

"Down With Disease" was released by Phish on June 2nd, 1993 as the first single from their 1994 album *Hoist*. This was their breakthrough single on American rock radio, reaching #33 on the Billboard Mainstream Rock Tracks chart in June of 1994. "Down With Disease" features the only music video that has been self-produced by the band.

93. The cover of Marilyn Manson's 3rd album "Mechanical Animals" features the singer with a streak of what color in his hair?

A. Blue

B. Green

C. Red

D. Yellow

Answer: C. Red

Marilyn Manson's third studio album "Mechanical Animals" features controversial album art with Manson on the cover fully nude, with breasts (sans nipples), lacking genitalia, and bright red hair atop inhumanly pale skin. This art led to a retailer ban and alternative album art from the artist.

94. Featuring the single "Pull Me Under", what was the title of the album released by Dream theater in 1992?

A. Images and Words

B. Letters and Numbers

C. Signs and Symbols

D. Noughts and Crosses

Answer: A. Images and Words

Images and Words (1992) is Dream Theater's most commercially successful album, being certified Gold by the RIAA, with the single "Pull Me Under" being the bands only Top 10 hit to date. This song has also since been featured in "Guitar Hero World Tour" in 2008.

95. "I know who I want to take me home" is a refrain heard in which rock song released in 1998?

A. Fly Away

B. Closing Time

C. Never There

D. Inside Out

Answer: B. Closing Time

"Closing Time" is the hit single by Semisonic, released in 1998. The song charted at 8th on the US Mainstream Top 40 and was nominated for the Grammy Award for Best Rock Song in 19999. The Song has since reappeared on charts in 2011 after being in the film "Friends With Benefits" and in the sitcom "The Office".

96. What following name is shared by a James Bond film and the band who recorded "Here in Your Bedroom" in 1996?

A. Goldfinger

B. Octopussy

C. Thunderball

D. Moonraker

Answer: A. Goldfinger

Goldfinger is an American punk band formed in 1994, taking inspiration for their name from the James Bond film of the same name. Goldfinger have since become legends in videogame soundtracks, having songs on Tony Hawk's Pro Skater, Tony Hawk's Pro Skater 4, Burnout Legends, and Shaun White Snowboarding.

97. Marilyn Manson's 1995 "Smells Like Children" album featured a cover of which popular song?

A. Wake Me Up (Before You Go-Go)
B. (I Can't Get No) Satisfaction
C. Sweet Dreams (Are Made Of This)
D. Break On Through (To The Other Side)

Answer: C. Sweet Dreams (Are Made Of This)

Marilyn Manson's 1995 cover of Eurythmics single "Sweet Dreams (Are Made Of This)" was the band's first legitimate hit record despite initial hesitance from the label to release it. The song charted at 31 on the US Mainstream Rock charts, and has since been placed on Marilyn Manson's greatest hits album

98. Before gaining success under their final name, which following band were once known as Small the Joy?

A. Cake
B. Fuel
C. Poison
D. Motorhead

Answer: B. Fuel

Brett Scallion's band Fuel was known as Small The Joy when the debuted in 1989, releasing a self titled cassete EP "Small the Joy" in 1994. The band decided to change their name in 1996, deciding on the name Fuel, and went on to sell millions of albums under the name with *Sunburn* being certified platinum and "Something Like Human" double platinum.

99. Released on the band's only studio album, which "Temple of the Dog" song opened with the line "I don't mind stealin' bread"?

 A. Hunger Strike
 B. Reach Down
 C. Wooden Jesus
 D. Your Saviour

Answer: A. Hunger Strike

"Hunger Strike" was the first single by supergroup Temple Of The Dog, peaking at #4 on the Billboard Mainstream Rock Tracks charts. Hunger Strike also features Eddie Vedder's first featured vocal, with him assisting Chris Cornell . Vedder remembers the song as "the first time I heard myself on a real record" and as "one of my favorite songs I've ever been on"

100. Releasing 7 albums over 20 years, the band Seven Mary Three took the inspiration for their name from which TV show?

 A. Hawaii Five-0
 B. Hill Street Blues
 C. CHiPs
 D. Starsky & Hutch

Answer: C. CHiPs

Seven Mary Three was an American Rock band best known for their hit single "Cumbersome", reaching number 1 on the US Mainstream Rock charts. Despite proving their ability to write a commercially successful hit, the band was never able to replicate this level of success and has pigeon-holed the band into many one-hit-wonders lists from the 1990's.

ANSWERS AND FUN FACTS: 101 - 120

101. The Offspring's sixth studio album, "Conspiracy Of One", featured a yellow flaming skull on a background circle of which color?

 A. Yellow
 B. Red
 C. Purple
 D. Green

Answer: B. Red

The Offspring's sixth studio album "Conspiracy of One" was released November 14th, 2000 by Columbia records. Despite the fact that The Offspring insisted peer-to-peer file sharing would not hurt sales (during the Napster era), the album ended up as a physical release when Columbia threatened to sue the band for attempting to release the album directly themselves through their website.

102. Released independently by Beck in 1993, which following song featured the line "Don't believe everything that you breathe"?

A. Lemon

B. Linger

C. Low

D. Loser

Answer: D. Loser

"Loser" was first released in March 1993 as a 12-inch vinyl single on Bong Load records, with only 500 copies pressed. Beck insisted that "Loser" was a mediocre song and only agreed to release it at the insistence of his label, though the song since reached number ten on the Billboard Hot 100 Singles chart and sold more than 600,000 copies domestically.

103. The lyrics "Sometimes it's my life I can't taste" came from which song on Korn's "Follow the Leader" album?

A. Freak on a Leash

B. Got the Life

C. Reclaim My Place

D. Dead Bodies Everywhere

Answer: A. Freak on a Leash

"Freak on a Leash" was the first Korn single following their 1998 album *Follow The Leader*. The Single peaked at number six on the Alternative Songs chart, and 10th on the Mainstream Rock Songs chart, going on to become one of the band's most recognizable songs.

104. With lyrics such as "You're a slave to money then you die", what kind of 'Symphony' did The Verve sing about in 1997?

A. Melancholy

B. Bitter Sweet

C. Poignant

D. Wistful

Answer: B. Bitter Sweet

"Bittersweet Symphony" by Verve is was the band's best selling song, and one of the defining tracks of the britpop era. The single reached number 12 on the Billboard Hot 100, and was nominated for Video of the Year, Best Group Video, and Best Alternative Video in the1998 VMAs as well as a Grammy Award for Best Rock Song.

105. Pioneers of the grunge era, brothers Gary and Van from the Screaming Trees had what surname?

A. Connolly
B. Conroy
C. Conlon
D. Conner

Answer: D. Conner

Gary and Van Connor's band Screaming Trees were known as one of the pioneers of grunge along with the Melvins, Mudhoney, U-Men, Skin Yard, Soundgarden, Green River, and Malfunkshun, all from Seattle or the surrounding area. Formed in 1985, the band spent 4 years of recording and touring before being picked up by Epic Records in 1990.

106. Released on the "Use Your Illusion 1" album was a Guns N Roses song featuring which month in the title?

A. February
B. April
C. September
D. November

Answer: D. November

Released on the same day, September 17th, 1991 "Use Your Illusion 1" and "Use Your Illusion 2" featured a release schedule unlike any other albums at the same time. While unconventional, each album has been certified 7x platinum by the RIAA while "Use Your Illusion I" was nominated for a Grammy in 1992

107. When Pantera released their fifth album in 1990, what type of characters were mentioned in the title?

 A. Indians
 B. Cowboys
 C. Thieves
 D. Spacemen

Answer: B. Cowboys

Cowboys From Hell was released by Pantera on July 24th, 1990 as their first major label debut and their first of many collaborations with producer Terry Date. The album is considered one of the first-ever groove metal albums and received almost universal praise from critics, since proving to be one of the most influential metal albums of all time.

108. In a 1991 song by Primus, what was the name of the racecar driver who "drove so goddamn fast"?

 A. Donny
 B. Jerry
 C. Ronny
 D. Terry

Answer: B. Jerry

"Jerry Was a Race Car Driver" was released as the first single from Primus' 1991 album *Sailing the Seas of Cheese.* The song reached number 23 on the US Alternative Songs chart and received positive reception from critics who found the single had a "memorable and distinctive sound"

109. The original bassist for Alice in Chains, Mike Starr was replaced by which musician in 1993?

 A. William DuVall
 B. Jerry Cantrell
 C. Mike Inez
 D. Sean Kinney

Answer: C. Mike Inez

Alice in Chains was formed in Seattle, Washington in 1987 by guitarist and vocalist Jerry Cantrell alongside drummer John Kinney, soon after recruiting bassist Mike Starr and frontman Layne Staley. Starr was replaced in 1993 with Mike Inez, and William DuVall joined the band to replace Layne Staley who passed away in 2002.

110. After "Hole" was founded in 1989 by Courtney Love and Eric Erlandson, which female musician was never part of the lineup?

 A. Suzi Gardner
 B. Patty Schemel
 C. Melissa Auf der Maur
 D. Kristen Pfaff

Answer: A. Suzi Gardener

Hole was founded in Los Angeles, California in 1989 by Courtney Love and Eric Erlandson. The band had several different drummers and bassists over the years, the best-known being drummer Patty Schemel

and bassists Kristen Pfaff (who passed away in 1994), and Melissa Auf Der Maur.

111. In the lyrics of "Mr Jones" by Counting Crows, the subject of the song painted themselves in "blue and red and black" and what other color?

 A. Green
 B. Grey
 C. Brown
 D. White

Answer: B. Grey

Mr. Jones was released by Counting Crows on December 1st, 1993 as the lead single from their debut album "August and Everything After". The song was the band's first radio hit and their breakout single, reaching number five on the Billboard Hot 100, remaining to date as their highest-charting single.

112. With a heavy emphasis on alternative rock, the soundtrack for "Last Action Hero" did not feature which of these bands?

 A. Megadeth
 B. Anthrax
 C. Korn
 D. Aerosmith

Answer: C. Korn

Last Action Hero was a 1993 film directed by John McTiernan, starring Arnold Schwarzenegger. While the film itself was released to little fanfare or positive media attention, the album was positively received by rock radio stations and was certified platinum on August 24th, 1993.

113. Covered by artists including Kelly Clarkson, The Corrs and Pink, REM's "Everybody Hurts" was originally on which album?

 A. Automatic for the People
 B. Out of Time
 C. Monster
 D. Up!

Answer: A. Automatic for the People

"Automatic for the People" is the eighth studio album by R.E.M., released on October 5th, 1992. Upon release, the album received widespread critical acclaim and reached number two on the US Billboard 200, with 6 different singles driving its success. *Automatic for the People* has since sold an astounding 18 million copies worldwide

114. According to the lyrics of her smash hit "You Oughta Know", Alanis Morisette sings of the "mess you made when you…" did what?

 A. Disappeared
 B. Took off
 C. Went Away
 D. Went to jail

Answer: C. Went Away

The lyrics are as follows:

> *"And I'm here, to remind you*
> *Of the mess you left when you went away"*

"You Oughtta Know" was one of Alanis Morissette's most popular singles, reaching 6th on the US Billboard Hot 100 in 1995. The song was widely rumored to have been written about Alanis Morssette's former flame Dave Coulier (of "Full House" fame), but neither party have confirmed this.

115. "They hold the reins and stole your eyes" is a lyric from Rage Against the Machine's "Guerilla Radio", but what album did the track come from?

 A. Rage Against the Machine
 B. Evil Empire
 C. The Battle of Los Angeles
 D. Renegades

Answer: C. The Battle Of Los Angeles

"The Battle of Los Angeles" was the third studio album by Rage Against the Machine, released on November 2nd, 1999. The album was nominated for Best Rock Album at the 43rd Annual Grammy Awards in 2001, and was referred to as the best album of 1999 by both Time and Rolling stone magazines.

116. With its title taken from the first line of the song, "If You Could Only See" was a hit for which following band?

 A. Collective Soul
 B. Dishwalla
 C. Tonic
 D. Blur

Answer: C. Tonic

"If you Could Only See" was Tonic's most successful single, reaching number 1 on the US Mainstream Rock charts in 1997 as well as 11th overall on the US Mainstream Top 40 charts. However, the band was able to receive two grammy nominations from their third album *Head On Straight* as well in 2002, leaving them far from the one-hit-wonder category.

117. They Might Be Giants released a single in 1990 with what animal accommodation in the title?

 A. Pig pen
 B. Dog kennel
 C. Bird house
 D. Chicken Coop

Answer: C. Bird house

They Might Be Giants "Birdhouse in Your Soul" was released on Elektra Records in late 1989 as the lead single from the album *Flood*. Birdhouse remains the bands highest-charting-single to date, while the album *Flood* received rave reviews from music critics for the quirkiness of subject matter and musical superiority over the bands previous endeavors.

118. Written by Gwen Stefani and Tom Dumont, "Just a Girl" was released on which No Doubt album?

 A. Tragic Kingdom
 B. The Beacon Street Collection
 C. Return of Saturn
 D. Rock Steady

Answer: A. Tragic Kingdom

Tragic Kingdom was released No Doubt on October 10th, 1995, becoming the band's most successful album. Tragic Kingdom reached number one on the Billboard 200 as well as receiving nominations for Grammy Awards for the Best New Artist and Best Rock Album. The album has sold over 16 million copies and has been certified Diamond by the RIAA.

119. In 1995, which band released a song that opened with the line "I am the Astro-Creep, a demolition style hell American freak yeah"?

 A. Danzig
 B. White Zombie
 C. Faith No More
 D. Testament

Answer: B. White Zombie

White Zombie, the Rob Zombie fronted noise and metal band, was formed in New York City in 1985. The song in question is "More Human Than Human" by White Zombie, the first official single from their album *Astro-Creep: 2000* (1995). The song reached 53rd on the US Hot 100 Airplay charts.

120. According to Matchbox 20 in the lyrics of "3AM", what emotion is described as a "mat that sits on her doorway"?

 A. Euphoria
 B. Delirium
 C. Happiness
 D. Contentment

Answer: C. Happiness

"3AM" is the third single from Matchbox 20's debut album *Yourself or Someone Like You* released on November 23rd, 1997. The song spent ten weeks atop the US Billboard Adult Pop Songs chart, but was not eligible for inclusion on the Billboard Hot 100 as it hadn't received a physical release in the United States.

ANSWERS AND FUN FACTS: 121 - 140

121. Reaching #1 in 3 different countries, "Iris" by the Goo Goo Dolls was originally written for the soundtrack of which 1998 movie?

 A. What Dreams May Come
 B. Sliding Doors
 C. Pleasantville
 D. City of Angels

Answer: D. City of Angels

"Iris", released April 1st, 1998 was one of the most significant songs in the success of the Goo Goo Dolls. The sonc reached number nine on the Billboard Hot 100 and is one of Ireland's best-selling singles of all time. "Iris" was nominated for Grammys for Record Of The Year and Best Pop Performance by a Duo or Group, going on to become quadruple platinum in sales as well.

122. The film clip for which song off the Stone Temple Pilots' "Purple Album" features a silent movie for the first 40 seconds?

A. Lounge Fly

B. Interstate Love Song

C. Vasoline

D. Big Empty

Answer: B. Interstate Love Song

Considered one of the bands biggest hits, "Interstate Love Song" is a Stone Temple Pilots single released on September 9th, 1994 from their second studio album "Purple" . One of the bands biggest hits, "Interstate Love Song" reached number one on the US Billboard Album Rock Tracks, remaining there for 15 weeks - replacing their own single "Vasoline" in the spot.

123. Featured on the album "Without You I'm Nothing", which Placebo song starts with the line "Sucker love is heaven sent, you pucker up, our passion's spent"?

A. You Don't Care About Us

B. My Sweet Prince

C. Every You, Every Me

D. Scared of Girls

Answer: C. Every You, Every Me

"Every You Every Me" was released by British band Placebo on January 25th, 1999. While the song charted in Australia, Germany, Iceland, Scotland and the United Kingdom, it was never able to break into the American market, being certified Silver in the UK with 200,000 sales.

124. Released in 1998 and featuring the hit single "Space Lord", what was the title of Monster Magnet's fourth album?

A. Egotrip

B. Powerhungry

C. Egomaniac

D. Powertrip

Answer: D. Powertrip

Released on June 16th, 1998, *Powertrip* was Monster Magnet's first commercial success, largely on the back of the single "Space Lord", charting at 97th on the US Billboard Hot 100, and reaching first place on the US Top Heatseekers chart in 1998. The album was certified Gold by the Recording Industry Associates of America.

125. Formed in Canada in 1992, rock band Our Lady Peace has been fronted by which member since its inception?

A. Steve Mazur

B. Raine Maida

C. Jason Pierce

D. Duncan Coutts

Answer: B. Raine Maida

Our Lady Peace is a Canadian band formed in Toronto, Ontario in 1992 by Raine Maida and featuring a steadily changing cast of members. The band has sold millions of albums worldwide and remain one of the most prolific Canadian rock bands of all time with nineteen of their singles reaching the Top 10 on Canadian Singles charts.

126. Regarded as their most popular work, which band released the album "Bringing Down the Horse" in 1996?

A. The Wallflowers

B. Toad the Wet Sprocket

C. Counting Crows

D. Third Eye Blind

Answer: A. The Wallflowers

Bringing Down the Horse is the Wallflowers second album. The album sold just over 4 million copies and included hits such as "One Headlight", "6th Avenue Heartache", "The Difference", and "Three Marlenas". The band was thrust into stardom through the enormous success of the album. To date, "Bringing Down the Horse" is the highest-selling Wallflowers album.

127. Achieving multi-platinum success with their second album "New Miserable Experience", the Gin Blossoms hailed from which American state?

A. Virginia

B. Arizona

C. Georgia

D. Massachusetts

Answer: B. Arizona

The American alternative rock band formed in 1987, hailing from Tempe, Arizona. Their name came from a picture in the book "Hollywood Babylon", showing entertainer W.C. Fields with rosacea (known colloquially as 'gin blossoms') on his nose and face.

128. In the lyrics of the Soundgarden song "Spoonman", the singer compares all his friends to which creepy characters?

A. Ghosts

B. Skeletons

C. Demons

D. Monsters

Answer: B. Skeletons

"Spoonman" was written by frontman Chris Cornell, and released on February 15, 1994. It was the first single from the band's fourth studio album, "Superunknown". 'Spoonman' is credited as one of the songs that launched Soundgarden's career into the mainstream. The song peaked at number three on the Billboard Mainstream Rock Tracks chart and number nine on the Modern Rock Tracks chart.

129. After signing with Interscope Records, which band released the album "Broken" in 1992?

 A. Nine Inch Nails
 B. Tool
 C. Jane's Addiction
 D. Deftones

Answer: A. Nine Inch Nails

"Broken' (also known as Halo 5) is the first extended play and second major release by Nine Inch Nails. The EP was produced by frontman Trent Reznor and Flood. It was released on September 22, 1992, by Nothing, TVT, and Interscope Records. The album's recording was done in secret to avoid interference from TVT Records.

130. Prior to his untimely death due to heart attack on stage in 1999, Mark Sandman was lead singer for which band?

 A. Morphine
 B. Portishead
 C. Cowboy Junkies
 D. Iron Maiden

Answer: A. Morphine

Morphine was formed in 1989 in Cambridge. Band Member Mark Sandman was an indie rock icon and longtime fixture in the Boston/Cambridge music scene. He was multi-talented; a singer, song-writer, musical instrument inventor, multi-instrumentalist, and even a comic writer.

At just 46, Mark Sandman died while performing live in July of 1996.

131. Covered by Guns N' Roses on their "Use Your Illusion 1" album, the song "Live and Let Die" was written by which former Beatles member?

 A. John Lennon
 B. Ringo Starr
 C. George Harrison
 D. Paul McCartney

Answer: D. Paul McCartney

"Live and Let Die" was the theme song in the 1973 classic James Bond. Paul McCartney co-wrote the anthem with better half Linda McCart-ney. It was the first rock song to open a Bond film. Live and Let Die was the most successful Bond theme up to that point, reaching No. 1 on two of the three major US charts. Not only that, it also became the first Bond theme song to be nominated for the Academy Award for Best Original Song!

132. Prior to achieving success under their current name, the band Linkin Park were known by what name?

 A. Phantaxm
 B. Xanax
 C. Baxaar
 D. Xero

Answer: D. Xero

The band, now famously known as Linkin Park, originally consisted of three high school friends. Xero's foundation was anchored by Mike Shinoda and Mark Wakefield, later joined by Brad Delson, Rob Bourdon, Joe Hahn, and Dave "Phoenix" Farrell. The band had humble beginnings, recording in Shinoda's makeshift bedroom studio in 1996.

133. Released in July 1993, the Smashing Pumpkins' second studio album was about what kind of "Dream"?

 A. Taiwanese
 B. Siamese
 C. Japanese
 D. Burmese

Answer: B. Siamese

"Siamese Dream" helped break Smashing Pumpkins into the musical mainstream. The album has since been considered "one of the finest alt-rock albums of all time." The album was released under Virgin Records in July of 1993. "Siamese Dream" debuted at number ten on the Billboard charts. Eventually, it was certified 4x Platinum, with the album selling over six million copies worldwide, making Smashing Pumpkins a staple group in alternative rock music.

134. 1991 was quite the year for rock music, but which of these bands was not formed in that year?

 A. Cake
 B. Incubus
 C. Oasis
 D. Creed

Answer: D. Creed

Creed began in 1994 in Tallahassee, Florida. The band consisted of lead vocalist Scott Stapp, guitarist and vocalist Mark Tremonti, bassist Brian Marshall, and drummer Scott Phillips. Creed has sold over 28 million records in the United States and sold over 53 million albums worldwide!

135. First formed in 1996 and headed up by the Madden twins, where did the band Good Charlotte get the inspiration for their name?

 A. A children's book
 B. A TV show
 C. A childhood friend
 D. A movie

Answer: C. A children's book.

Inspired by a Beastie Boys concert in 1995, twin brothers Joel and Benji Madden formed Good Charlotte in Waldorf, Maryland, with Joel on vocals and Benji on guitar. After high school, the brothers focused full time on pursuing their dream of making a band. Good Charlotte's debut eponymous studio album was released on September 26, 2000 through Epic and Daylight Records.

136. With all members having been with the band since inception, which musician sings lead vocals for Simple Plan?

 A. Chuck Comeau
 B. Pierre Bouvier
 C. Jeff Stinco
 D. Sebastian Lefebvre

Answer: B. Pierre Bouvier

Bouvier met his best friend Chuck Comeauat a Sugar Ray concert as a teen. Together they created Simple Plan along with old schoolmates David Desrosiers, Jeff Stinco, and Sébastien Lefebvre.

The band hails from Canada, specifically Montreal, Quebec, and formed in 1999. The band has released five studio albums: "No Pads, No Helmets...Just Balls" (2002), "Still Not Getting Any..." (2004), "Simple Plan (2008), "Get Your Heart On!" (2011), and "Taking One for the Team" (2016).

137. Featured on the band's "Californication" album, which Red Hot Chili Peppers track contains the refrain "With the birds I'll share this lonely viewin' "?

 A. Around the World
 B. Otherside
 C. Scar Tissue
 D. Parallel Universe

Answer: C. Scar Tissue

"Scar Tissue" is the first single from the Red Hot Chili Peppers' seventh studio album, "Californication", released in 1999. The song spent 16 consecutive weeks atop the US Billboard Hot Modern Rock Tracks chart. "Scar Tissue" was an international success, breaking multiple records of its time.

138. Releasing their debut album in 1992, the Manic Street Preachers hail from which country of the UK?

 A. Wales
 B. Scotland
 C. Ireland
 D. England

Answer: A. Wales

Manic Street Preachers were classmates at Oakdale Comprehensive School, Blackwood, South Wales. They officially formed the band in 1986. The story has it that the band's name originated from an altercation one of the members had in which someone asked him, "What are you, boyo, some kind of manic street preacher?"

139. What are the first names of the twin sisters who both sing and play guitar for The Breeders?

 A. Kat and Kasey
 B. Kylie and Kirsty
 C. Kate and Krystal
 D. Kim and Kelley

Answer: D. Kim and Kelley

The Breeders hail from Dayton, Ohio, and were formed in 1989. Along with twin sisters Kim and Kelley, the band consists of Josephine Wiggs on the bass guitar and vocals, and Jim Macpherson on drums. The band was originally a side project, but eventually began gigging full time after the 1993 break up of the band Pixies.

140. Recorded on R.E.M's "Monster" album was a track with what male name in the title?

 A. Matthew
 B. Kenneth
 C. David
 D. Roger

Answer: B. Kenneth

"What's the frequency, Kenneth?" Is from R.E.M's ninth studio album, "Monster". The song's title refers to an incident in New York City in 1986, when two then-unknown assailants attacked journalist Dan Rather, while repeating "Kenneth, what is the frequency?"

ANSWERS AND FUN FACTS: 141 - 160

141. Which common substance is also the title of a Bush song from 1995?

 A. Peroxide
 B. Lanolin
 C. Borax
 D. Glycerine

Answer: D. Glycerine

"Glycerine" was released on 14 November 1995 as the fourth single from their debut album, "Sixteen Stone". It reached number one on the Modern Rock Tracks chart for two weeks, in December 1995. It is also the band's biggest pop hit to date, peaking at number 28 on the Billboard Hot 100 on 24 February 1996.

142. Released in 1993, "Undertow" was the debut studio album by which rock band?

 A. Tool

B. Suede

C. Extreme

D. Eightball

Answer: A. Tool

As of 2020, "Undertow" has sold over three million copies in the United States, and is certified triple platinum by the Recording Industry Association of America. Allmusic states "Undertow" helped heavy metal music remain prominent as a mainstream musical style, and allowed several later bands to break through to the mainstream.

143. English musician Jarvis Cocker found fame as the frontman of Pulp, but what accessory became part of his trademark appearance?

A. Bow tie

B. Walking stick

C. Beret

D. Glasses

Answer: D. Glasses

Cocker founded the band Pulp at the young age of 15. The band found fame in the 1990s with the success of the albums "His 'n' Hers" (1994) and "Different Class" (1995). Cocker became famous for his glasses, which stayed attached to his face seemingly by magic. Unbeknown to concert-goers, they were held in place with a big rubber band, concealed by Cocker's hair.

144. Appearing on the band's 1992 "Dirt" album, which Alice in Chains song was a tribute to the lead vocalist of Mother Love Bone?

A. Would?

B. Junkhead

C. Sickman

D. Angry Chair

Answer: A. Would?

"Dirt" was released on September 29, 1992, and is Alice In Chains second album. Would was written by guitarist and vocalist Jerry Cantrell as a tribute to his friend Andrew Wood, lead vocalist of Mother Love Bone, who died in 1990. Cantrell sings the verses of the song, while Layne Staley sings the chorus.

145. The members of which following band met while attending the same school in England?

 A. Radiohead
 B. Gorillaz
 C. Blur
 D. The Verve

Answer: A. Radiohead

The members of Radiohead all met while attending Abingdon School in Oxfordshire. Thom Yorke (vocals) and Colin Greenwood (bass) were in the same year. Ed O'Brien (guitar and vocals) and drummer Philip Selway were in the year above, and multi-instrumentalist Jonny Greenwood, brother of Colin, was two years below.

Radiohead recorded its debut release, "Drill:, inMay 1992; unfortunately, its chart performance was poor. When "Creep" was released, Radiohead began to receive attention in the British music press, although not always favorable.

146. Known for the 1992 album "The Southern Harmony and Musical Companion" is which band hailing from Marietta, Georgia?

 A. The White Doves

B. The Black Crowes

C. The Screaming Eagles

D. The Flaming Peacocks

Answer: B. The Black Crowes

Brothers Rich and Chris Robinson founded the Black Crowes while they were still in high school, and have always been active members of the band despite its ever-changing line-up. (The Black Crowes have had more than thirteen different members throughout its history.) Two of the band's biggest hits, "Remedy" and "Sting Me", are included on their second album, "The Southern Harmony and Musical Companion". It's interesting to note that this album is titled after a hymn book compiled in 1835 by William Walker.

147. What title was given to the lead single from Blur's third album, "Parklife"?

A. Men & Women

B. Ladies & Gentlemen

C. Chicks & Guys

D. Girls & Boys

Answer: D. Girls & Boys

The band *Blur*, originally named *Seymour*, released their third album Parklife in the Spring of 1994. This album achieved commercial success, peaking at number 1 on the U.K Albums chart, while the single "Girls & Boys" also became a hit and peaked at number 5 on the U.K Singles Chart. As a point of interest, the band's frontman Damon Albarn also co-founded *The Gorillaz* and is the lead vocalist and song-writer of the virtual band. Blur's drummer Dave Rowntree became a politician with the Labour Party.

148. Featuring the lyrics "Flip on the telly, wrestle with Jimmy" was which 1994 Weezer song?

A. My Name is Jonas
B. Only In Dreams
C. Say It Ain't So
D. No One Else

Answer: C. Say It Ain't So

This successful song was included on Weezer's first album, *Weezer*, also known as the "Blue Album". Also included on this album were the songs "Buddy Holly" and "Undone", which performed well on the U.S and U.K charts. "Say It Ain't So" has gained popularity since the 90s and has been covered by several singers including *Foster The People*. The inspiration for the song came from frontman Rivers Cuomo's experience growing up with his alcoholic father and how it affected his family.

149. Prior to leaving the music industry to pursue a career as a visual artist, Justine Frischmann was the lead singer of which band?

A. Elastica
B. Suede
C. Republica
D. Lash

Answer: A. Elastica

Elastica was formed in 1992 and was active for nine years until its break-up in 2001. During their active years, the band only recorded two studio albums that performed well on the charts in several countries, the U.K in particular. Elastica's most successful single is "Connection", which became a top 5 song in the U.S and Canada. It's interesting to note that Justine Frischmann, the founder of Elastica, also co-founded Suede with Brett Anderson and Mat Osman.

150. The cover of Oasis album "(What's the Story) Morning Glory?" features two men on which iconic London roadway?

 A. Abbey Road
 B. Berwick Street
 C. Brick Lane
 D. Piccadilly

Answer: B. Berwick Street

Although this iconic album cover reportedly cost £25,000 to make, one can argue that it was money well spent, since this album is Oasis' most commercially successful album ever! The band released "(What's The Story?) Morning Glory in 1995 following the release of their first studio album titled "Definitely Maybe" the previous year. (*What's The Story) Morning Glory* included some of Oasis' biggest hits like "Wonderwall" and "Don't Look Back in Anger" and has been certified 16-times platinum in the U.K as of 2021.

151. Alternative rock band The Boo Radleys took their name from a character in which classic novel?

 A. The Catcher In The Rye
 B. Slaughterhouse-Five
 C. To Kill a Mockingbird
 D. Animal Farm

Answer: C. To Kill a Mockingbird

The Boo Radleys formed in 1988 and released six studio albums before breaking up eleven years later in 1999. The band's biggest hit was the cheerful, upbeat pop song "Wake Up Boo!" from their fourth album titled "Wake Up!". The Boo Radleys reunited in 2020, and a year later, released their first single since they disbanded. Martin Carr, the band's frontman, explained that they chose the name "Boo Radley" for the band because they "just thought it was a cool name".

152. Which following rock band formed in 1993 includes brothers Gaz and Rob Coombes?

 A. The Hotrats
 B. Pulp
 C. Supergrass
 D. Primal Scream

Answer: C. Supergrass

The band Supergrass was originally named "Theodore Supergrass" by founders Mick Quinn, Danny Goffey, and Gaz Coombes. Gaz's brother Rob joined the band in 2002, nine years after it was formed. The band achieved their biggest hit with the song "Alright" which peaked at number 2 on the U.K singles chart in the summer of 1995. The song's success is largely attributed to the movie "Clueless", due to the song being included on the film's soundtrack and the film becoming a hit grossing $56,631,572 worldwide upon its release.

153. Which following band were forced to change their name after drawing unwanted attention from a similar-named irish band?

 A. Blink-182
 B. The Offspring
 C. Good Charlotte
 D. Ben Folds Five

Answer: A. Blink-182

Before establishing themselves as the hit-making band known as Blink-182, the band originally went by the name "Blink". However, they were forced to change their name after an Irish band also called "Blink" threatened to take legal action against them if they didn't go by another name. According to band member Mark Hoppus, the "182" added to the band's name had no significance to them when they chose

it. This has not stopped the band from playfully assigning random meanings to the number.

154. What was the title of the Ramones 14th and final studio album, released in 1995?

 A. So Long, and Thanks for All the Fish
 B. Adios Amigos!
 C. Good Riddance
 D. Smell Ya Later

Answer: B. Adios Amigos!

Legendary punk-rock group The Ramones emerged on the music scene in 1974 and departed in 1996 after a successful career. Despite the band members all having the last name Ramone, none of them were actually related. They each chose their own stage names, each one ending with Ramone. John Cummings chose the name Johnny, Thomas Erdelyi was known as Tommy, Douglas Colvin was called Dee Dee and Jeffrey Hyman was known as Joey. The band's last album peaked at number 62 on the UK charts.

155. Which following Pearl Jam track was not included on the band's 1992 "MTV Unplugged in New York" album?

 A. On a Plain
 B. Dumb
 C. Garden
 D. Polly

Answer: C. Garden

It's interesting to note that Pearl Jam's live album "MTV Unplugged in New York" was recorded in 1992, but only released to the public 23 years

later. In the U.S, the 7-track album peaked at number 47 on the Billboard 200 and entered the charts in several other countries. All four founding members of the band (Eddie Vedder, Stone Gossard, Mike McCready, and Jeff Ament) have remained in the line-up throughout its history. As of 2021, the band has released ten albums and has won two Grammys.

156. Which of the following rock groups did not hail from California?

 A. Jane's Addiction
 B. Green Day
 C. Rage Against The Machine
 D. Veruca Salt

Answer: D. Veruca Salt

Veruca Salt was formed in Chicago, a city that is also the birthplace of rock bands like The Smashing Pumpkins and Chicago. An interesting point to note is that the rock band Seether is named after the Veruca Salt song of the same name. This song was actually the band's first single and one of their biggest hits. Another interesting fact about this band is the origin of its name; the band was named after the spoiled little rich girl in the book "Charlie and the Chocolate Factory".

157. Released in October 1994, "Cigarettes & Alcohol" was a single by which British band?

 A. The Stone Roses
 B. Pulp
 C. The Verve
 D. Oasis

Answer: D. Oasis

This song was released on Oasis' first studio album titled "Definitely Maybe". The lyrics of "Cigarettes & Alcohol" explain why the average

working-class citizen might use these stimulants. Interestingly, 70s rock band T. Rex accused Oasis of copying part of their song "Get It On", which sounds strikingly similar to another song called "Queenie" which was written by Chuck Berry. Luckily for Oasis, they were never sued, and in spite of this controversy, the song achieved a considerable degree of success on the U.K charts and was certified platinum.

158. Best known as a rhythm guitarist for the Foo Fighters, Pat Smear was the touring guitarist for which band from 1993 to 1994?

 A. Alice in Chains
 B. Nirvana
 C. Guns N' Roses
 D. Poison

Answer: B. Nirvana

Pat Smear was not the only former Nirvana band member to play with the Foo Fighters; Krist Novoselic also contributed his accordion skills to one of the band's albums, and of course Dave Grohl is the band's drummer. Nirvana was founded in 1987 and produced three studio albums including the iconic "Nevermind" which was released in 1991. The band won a Grammy award two years after it disbanded following the untimely death of frontman Kurt Cobain.

159. The song "Karma Police" was released as the second single from which Radiohead album?

 A. Kid A
 B. The Bends
 C. OK Computer
 D. Amnesiac

Answer: C. OK Computer

Radiohead's third album OK Computer achieved a considerable amount of success, topping the charts in several countries including Norway and the U.K. The 5-times platinum album also received nominations for a Brit Award and the Mercury Prize, but only won a Grammy. Every member of Radiohead contributed to the composition of the song "Karma Police", which was inspired by a running inside joke that the band had. Another successful track from OK Computer was "No Surprises", which was certified gold in the U.K, Italy and Canada.

160. The first verse of the Korn "Shoots and Ladders" has lyrics taken from which nursery rhyme?

 A. Ring Around The Rosie
 B. Three Blind Mice
 C. Baa Baa, Black Sheep
 D. Rock-a-bye Baby

Answer: A. Ring Around The Rosie

This song by metal band The Korn actually samples the lyrics of several nursery rhymes – six, to be exact. In the third and fourth verses, the band sings the popular children's rhymes "One, Two, Buckle my Shoe" and "London Bridge Is Falling Down". The song's title is also a play on the name of the board game Chutes and Ladders (also called Snakes and Ladders). The band's inspiration for the song was the fact that children sing nursery rhymes, not knowing what they really mean.

ANSWERS AND FUN FACTS: 161 - 180

161. Which superhero is mentioned in the title of a track from the Flaming Lips album, "The Soft Bulletin"?

 A. Batman
 B. Wonder Woman
 C. Superman
 D. Catwoman

Answer: C. Superman

The song "Waitin' for Superman" was released on The Flaming Lips' ninth album The Soft Bulletin. The band's lead singer Wayne Coyne revealed that the song's lyrics were inspired by his father's unfortunate battle with cancer and death. Besides "Waitin' for Superman", the song "Race for the Prize" from The Soft Bulletin also performed well on the charts. As of 2021, the band has released 22 studio albums and have won three Grammy awards: two of them for "Best Rock Instrumental Performance".

162. Which of the following is both a 1992 song by Indigo Girls, and a character mentioned in Queen's "Bohemian Rhapsody"?

 A. Galileo
 B. Scaramouche
 C. Figaro
 D. Beelzebub

Answer: A. Galileo

This song was released on the Indigo Girls' 1992 album Rites of Passage. It was written by Emily Saliers and is based on the story of famous Italian astronomer Galileo Galilei. It was the first song by the group to climb into the top ten on any chart and was one of their biggest hits. The female duo has been active since 1985 and has produced sixteen studio albums, won a Grammy award, and received six more Grammy nominations.

163. Which word beginning with R was also the name of the lead single from New Order's 1993 album?

 A. Remorse
 B. Revenge
 C. Regret
 D. Repentance

Answer: C. Regret

Released in 1993 on their sixth album, "Regret" was the New Order's most successful song. The single ranked within the top 40 on the music charts in several countries and saw further success with quite a few remixed versions. New Order was formed by Peter Hook, Stephen Morris, and Bernard Sumner following the tragic collapse of their first band Joy Division. The band temporarily broke up after releasing their 1993 album Republic but got back together five years later and released their next album in 2001.

164. The cover of Blur's 1994 "Parklife" album featured images of which dog breed?

 A. Dachshund
 B. Greyhound
 C. Chihuahua
 D. Alsatian

Answer: B. Greyhound

Blur's 1994 album Parklife was the band's third album and spawned hits such as "Girls & Boys", "This Is a Low", and "End of a Century". This album achieved commercial success, peaking at number 1 on the UK Albums Chart. The band revealed that the album's cover was originally going to have a picture of a vegetable/ fruit cart, and the album was to be named "London". The dogs on the album cover refer to the sport of greyhound racing, which is popular in the U.K.

165. The lyrics "Little fish, big fish, swimming in the water. Come back here, man, gimme my daughter" form the opening line from a song by which artist?

 A. Edie Brickell
 B. PJ Harvey
 C. Regina Spektor
 D. Kate Bush

Answer: B. PJ Harvey

Polly Jean Harvey, better known as PJ Harvey, began her solo career in the mid-90s after working with the bands Automatic Dlamini and the PJ Harvey Trio. Her song "Down by the Water" was released on her third solo album and did pretty well on the U.S and U.K charts. The song is perhaps best known for its catchy lyrics "Little fish, big fish, swimming in the water/ Come back here, man, gimme my daughter".

166. The song "Army of Me" by Bjork was featured in which 1995 movie?

 A. GoldenEye
 B. Tank Girl
 C. Major Payne
 D. Mortal Kombat

Answer: B. Tank Girl

This single was the first of Björk's songs to rank in the top 10 on the U.K Singles charts. It also topped the charts in her native country, Iceland. The bizarre music video shows Bjork driving a tank, going to the dentist, wrestling a gorilla, and bombing a museum. This video caused a bit of a controversy and ultimately was not shown on MTV. The song "Army of Me" was included on Björk's second album *Post* which received several awards and nominations including a Grammy nomination.

167. Which Metallica song opens with the lyrics "So close, no matter how far, couldn't be much more from the heart"?

 A. Enter Sandman
 B. The Unforgiven
 C. Sad But True
 D. Nothing Else Matters

Answer: D. Nothing Else Matters

Legendary rock band Metallica released "Nothing Else Matters" on their fifth album titled "Metallica". This successful song received gold and platinum certifications in several countries including Australia, Germany and Sweden. The album "Metallica" also spawned hits such as "Sad but True", "Wherever I May Roam", and "Enter Sandman", the latter of which peaked at number 5 on the U.K Singles chart. Band

member James Hetfield reportedly wrote the song after feeling home-sick while on tour with the band.

168. Which band, formed in LA in 1990, is best-known for the 1993 hit "No Rain"?

 A. Mother Love Bone
 B. Blind Melon
 C. Stone Temple Pilots
 D. Mad Season

Answer: B. Blind Melon

Blind Melon's very alternative spin on rock music played a huge part in the band's success. They won many awards throughout their time. They formed in 1990 and there were five original members of the band. Their song "No Rain" ranked high on the charts including the Billboard Hot 100 and other international charts.

169. What do rock band U2 urge listeners to do in the refrain of their 1991 hit "One"?

 A. Love One Another
 B. Carry Each Other
 C. Help Each Other
 D. Stick Together

Answer: B. Carry Each Other

U2 are well-known for their longevity, and the fact that their lineup hasn't changed over multiple decades. The inspiration for "One" came about because of a chord progression that one of the members discovered. It's been said multiple times by the band that that this song saved them from breaking up.

170. Which female singer had her first brush with fame when she won a radio contest to perform with Shania Twain in 1999?

 A. Katy Perry
 B. Michelle Branch
 C. Nelly Furtado
 D. Avril Lavigne

Answer: D. Avril Lavigne

Avril Lavigne grew up in a musical family; her father played in a band, and their basement was converted into a music studio. She won the opportunity to sing on stage with Shania Twain at just 14 years of age. And her professional career took off shortly thereafter. Lavigne has won numerous awards and nominations, including being nominated for eight Grammy awards.

171. According to the lyrics of Nirvana's hit "Come As You Are", you can "come, doused in mud, soaked in..." which substance?

 A. Wine
 B. Bleach
 C. Blood
 D. Sweat

Answer: B. Bleach

Nirvana were first formed in 1987, and were together seven years. They sold over 75 million records while reaching top levels on different ranking charts. They landed on Billboard 100 charts, 100 greatest artists of all time charts and were eventually in the Rock and Roll Hall of Fame. Their song "Come As You Are" is about their journey to where they ended up.

172. A huge hit in 1999, the song "Smooth" was a collaboration between Carlos Santana and the frontman of which band?

 A. Nickelback
 B. Goo Goo Dolls
 C. Matchbox 20
 D. 3 Doors Down

Answer: C. Matchbox 20

The Matchbox 20 song "Smooth" became a hit as soon as it was released, topping the Billboard Hot 100 for 12 weeks. The song was an international hit, charting very highly in the UK, Canada and Australia. Interestingly, it was the first chart-topping song in Carlos Santana's long and illustrious career - his previous best effort was number 4 in 1971 with "Black Magic Woman".

173. Released in 1998, Aerosmith's "I Don't Want To Miss A Thing" was used in which following movie?

 A. Armageddon
 B. Deep Impact
 C. City of Angels
 D. Hope Floats

Answer: A. Armageddon

The entire Armageddon movie's Soundtrack was created by Aerosmith. In the movie, a gigantic asteroid comes towards Earth, so NASA sends drillers to avoid the collision. Armageddon was responsible for creating a soundtrack that was reflective of the movie storyline. In this song, everyone fears what is going to happen if the Asteroid hits Earth.

174. Which following name is not mentioned in the first verse of Sheryl Crow's "All I Wanna Do"?

A. Mac
B. Joey
C. Buddy
D. Billy

Answer: B. Joey

With nine Grammy awards and 32 nominations, Sheryl Crow is a legend of the music industry. "All I Wanna do" is one of her best performing songs, having sat at number two on the Billboard 100 for six weeks. The lyrics were based on a poem by Wyn Cooper entitled "Fun", with the melody coming from a song that Sheryl Crow had written previously but didn't like the original lyrics.

175. In 1999, the Cardigans collaborated with which singer in a cover of the Talking Heads song "Burning Down The House"?

A. Neil Sedaka
B. Tom Jones
C. Barry Manilow
D. Tony Bennett

Answer: B. Tom Jones

Tom Jones recorded a cover of "Burning Down the House" with The Cardigans as part of his 1999 collaborations album. The song became one of the major hits of the latter half of Tom Jones's career, and was hugely popular in Australia and across much of Europe. Interestingly, this was a feat that the Talking Heads couldn't achieve with the original song in 1983.

176. As heard in the Barenaked Ladies hit "One Week", it's been "One week since you looked at me", but how long since you "laughed at me"?

A. 5 days

B. 12 days

C. 4 days

D. 6 days

Answer: A. 5 days

The Barenaked Ladies formed in 1991, and initially had a cult following in Canada. "One Week" was the opening track on their 1998 album, "Stunt", and is notable for the number of references made to popular culture. The song has featured in various movies and TV shows, including "American Pie", "10 Things I Hate About You" and "The West Wing".

177. All of these songs reached #1 on the Billboard Modern Rock Tracks charts in the 90s, but which one was released the earliest?

A. Daughter - Pearl Jam

B. 1979 - Smashing Pumpkins

C. Sex and Candy - Marcy Playground

D. Give It Away - Red Hot Chili Peppers

Answer: D. Give It Away - Red Hot Chili Peppers

"Give it Away" is one of the Red Hot Chili Peppers' earliest and most awarded, and most popular songs. 29 years after its release, the song has been performed more than 775 times, more than any other Red Hot Chili Peppers song. The song is about altruistic behavior and self-lessness, with lyrics written by Anthony Keidis.

178. Which following Green Day song was not on their 1995 "Insomniac" album?

A. Geek Stink Breath

B. No Pride

C. Basket Case

D. Brat

Answer: C. Basket Case

Formed in 1987, Green Day released their "Insomniac" album in 1995. While reviews were generally positive, the album didn't quite hit the sales and longevity of "Dookie". This was largely attributed to its heavier sound and more somber themes - such as anxiety and drug use - when compared to the band's previous work. 2021 marked 25 years since the album's debut, with a deluxe version (including live tracks) released to mark the occasion.

179. Many rock musicians are known as much for meeting their demise prematurely as they are for their musical prowess. Which of these rock musicians died the youngest?

A. Jeff Buckley

B. Andrew Wood

C. Kurt Cobain

D. Freddie Mercury

Answer: B. Andrew Wood

Andrew Wood was lead singer and lyricist for Malfunkshun and Mother Love Bone. With his musical aspirations beginning at age 14, Wood grew to rely on drugs to maintain his rock and roll persona and lifestyle. Unlike many other similar musicians, Wood had a flamboyant style reminiscent of glam rock, that was influenced by the likes of Freddy Mercury, Marc Bolan and Jim Morrison.

180. What question did Blink 182 ask in the lead track off their "Enema of the State" album?

A. What's Your Name?

B. What's Going On?

C. What's Happening Next?

D. What's My Age Again?

Answer: D. What's My Age Again?

Blink 182 is a rock band that has had much success throughout their career. They had many hit singles and have sold over fifty million albums. They are currently still an active group. They have also been one of the most influential rock bands of all time. Their song "What's My Age Again?" is one of their biggest hits that have contributed to their success.

181. Released in 1990, what was the medical-sounding title of Judas Priest's twelfth studio album?

 A. Bandage
 B. Painkiller
 C. Anaesthetic
 D. Tranquilizer

Answer: B. Painkiller

Judas Priest is a heavy metal rock band that is recognized as one of the greatest rock bands. They have sold over 50 million copies of their music and still continue to experience success to this day. They continue to travel on tour all over the world. They were nominated for a grammy for their work on the song "Painkiller" off of this very same album. It was one of their most well-known albums.

182. Certified 3 times platinum in the U.S., "Tidal" was a 1996 album by which female singer?

A. PJ Harvey

B. Bjork

C. Feist

D. Fiona Apple

Answer: D. Fiona Apple

Fiona Apple is a rock performa that has been working in the industry since 1994. She reached numerous Billboard charts with her music and albums. She continues to tour and create music to this day. She also won numerous awards including three Grammy Awards. Her very first album, Tidal, brought her much success. She won a Grammy Award for it and was certified 3 times platinum.

183. What breakfast cereal was included in the title of one of Tori Amos' signature tracks, released in 1994?

A. Cornflakes

B. Cheerios

C. Rice Krispies

D. Lucky Charms

Answer: A. Cornflakes

Tori Amos is a well known rock singer and has won numerous awards for her work. She broke out as a soloist at the beginning of the 90s and has worked her way up ever since then. She has had eight Grammy nominations and is on the list for "Top 100 Greatest Women of Rock and Roll." She started performing in 1979 and has reached much famed success for all of her work since then.

184. 4 Non Blondes achieved chart success in 1993 with which single?

A. What's Up?

B. Spaceman

C. Morphine & Chocolate

D. Pleasantly Blue

Answer: A. What's Up?

4 Non Blondes is a rock band that formed in 1989. They were not nominated for several awards and won an award in the Danish Music Awards. Even though they were only active for five years, they achieved much success throughout the world including reaching number one spots in many of the European countries. Each of the members are still active today with either a solo career or with another band.

185. Formed in 1993 in Madison, Wisconsin, Garbage is fronted by which female vocalist?

A. Chrissie Hynde

B. Shirley Manson

C. Courtney Love

D. Delores O'Riordan

Answer: B. Shirley Manson

Formed in 1993, the lineup of Garbage has not changed since its inception. Duke Erikson and Butch Vig had performed together in several bands prior to joining forces with Shirley Manson and Steve Marker. The inspiration for their name came when a friend heard them rehearsing, and said they sounded like garbage.

186. "Sparkle and Fade" was the first album released under Capitol Records by which band?

A. Wheatus

B. Gin Blossoms

C. Everclear

D. Collective Soul

Answer: C. Everclear

Everclear is a rock band that was formed in 1991. They have experienced much success throughout their career and are well known for their songs and albums that they have created. "Sparkle and Fade" was released through Capitol Records. This album was certified Platinum and ranked high on the Heatseekers Chart throughout its high. It was actually such a well known and successful album that they recreated the album again in 1996.

187. First formed in 1983 and active in the 90's, which following band is one of the 'Big 4' of American thrash metal?

 A. Overkill
 B. Dark Angel
 C. Destruction
 D. Megadeth

Answer: D. Megadeth

Megadeth is a rock band that was formed in 1983. They have had numerous Platinum selling albums that brought them much success throughout their time. Megadeth was able to sell over 38 million albums and they were also nominated for twelve different Grammy awards. They finally won a Grammy Award for their song "Dystopia." They have had to switch out many different members of the band over the years but, all in all, they have stayed intact throughout their almost 40 year career.

188. What sea creature was mentioned in the title of the third studio album by Limp Bizkit?

 A. Octopus

B. Starfish

C. Dolphin

D. Sea urchin

Answer: B. Starfish

Limp Bizkit is a rock band that was formed in 1994. When they formed, he wanted to combine the music of rock and hip hop for his band. They have also experienced much success throughout their career. They have been nominated for three different Grammy Awards as well as many different other awards. They also sold over 40 million albums throughout their career. Limp Bizkit was one of the most influential groups to exist and set the stage for many more groups to come.

189. In 1996, David Lee Roth temporarily reunited with which band that he'd originally left in the mid-1980s?

A. Motley Crue

B. Van Halen

C. Def Leppard

D. Bon Jovi

Answer: B. Van Halen

After parting ways in 1984, Roth recorded two new with Van Halen for the 1996 greatest hits album, *Best Of - Volume I.* Van Halen parted ways again with Roth after the 1996 MTV Video Music Awards, opting instead for Extreme singer Gary Cherone for 1998's *Van Halen III.* Roth would rejoin Van Halen in 2007, resuming his role as the band's frontman until their final show in 2015.

190. Which of these alcoholic beverages is not mentioned in the lyrics of Chumbawumba's "Tubthumping"?

A. Vodka

B. Bourbon

C. Lager

D. Cider

Answer: B. Bourbon

"Tubthumping"was written as a testament of the resolve of ordinary people. Chumbawumba guitarist Boff Whalley was inspired by an Irish neighbor, who would often come home intoxicated from the nearby pub. Struggling to get into his home, the neighbor would fall to the ground and get back to his feet over and over again, never giving up on getting inside. "Tubthumping" helped the band sell over 3 million copies of the "Tubthumper" in the United States alone.

191. Prior to solo success with her albums "Debut" and "Post", Icelandic singer Bjork was a member of which band?

 A. The Coffee Beans
 B. The Teabags
 C. The Sugarcubes
 D. The Honeypots

Answer: C. The Sugarcubes

Formed in 1986, The Sugarcubes are considered by many to be the most popular band to ever emerge from Iceland. In 1988, the group achieved unexpected international success with their debut album, "Life's Too Good". The Sugarcubes would release two more albums before disbanding in 1992. Bjork would begin a solo career that has lasted nearly three decades, selling 20-40 million albums worldwide, making her a member of the most popular band and the most popular artist in Icelandic history.

192. Famously used as the "Friends" theme song, "I'll Be There For You" was recored by a band with which 'artistic' name?

A. The Rembrandts

B. The Van Goghs

C. The Monets

D. The Picassos

Answer: A. The Rembrandts

After REM turned down the use of their hit "Shiny Happy People " as the theme for "Friends" , Warner Brothers chose The Remembrandts (the only available band on their record label) to record the theme. Written by the "Friends" production team, "I'll Be There For You" sat atop the US Billboard Hot 100 Airplay chart for eight weeks, and is one of the most iconic TV themes of all time.

193. In 1998, the Offspring thought they were "Pretty Fly" for what kind of guy?

A. An old guy

B. A young guy

C. A white guy

D. A tall guy

Answer: C. A White Guy

"Pretty Fly (For A White Guy) " was the first of four singles from The Offspring's multi-platinum *Americana* album. According to guitarist/vocalist Dexter Holland, the song is aimed at wannabees, specifically drawing examples of kids in his native California who desperately attempted to mimic rap/hip hop culture. The nonsense, German-esque count in at the song's start was sampled from Def Leppard's "Rock of Ages", originally spoken by legendary producer Mutt Lange - who also produced "Americana".

194. Originally released in 1998, the film clip from which following song features a stylised fetus in utero singing the lyrics?

A. Closing Time
B. Fly Away
C. Teardrop
D. Slide

Answer: C. Teardrop

The second single from Massive Attack's 1998 album "Mezzanine", "Teardrop" was originally supposed to be sung by Madonna. In a 2-1 vote, the group instead chose ex-Cocteau Twins singer Elizabeth Fraser, whose otherworldly voice was deemed more appropriate for the song's tone. Fraser has stated the song's somber lyrics were inspired by the tragic death of ex-lover/fellow musician Jeff Buckley. With its heartbeat sounding beat, "Teardrop" would be used as the opening theme of Fox's hit TV show, "House".

195. According to the lyrics of Sinead O'Connor's "Nothing Compares 2 U", it's been 7 hours and how many days?

A. 13
B. 15
C. 19
D. 16

Answer: B. 15

Originally written by Prince for the debut album of his solo project The Family, Sinead O'Connor's cover of "Nothing Compares 2 U" from her 1990 sophomore effort "I Do Not Want What I Haven't Got" is considered to be her breakthrough hit. It sat atop the Billboard Hot 100 for four weeks and was named the #1 World Single at the inaugural Billboard Music Awards in 1990. "Nothing Compares 2 U" would help the album sell over 7 million copies worldwide, and is still considered O'Connor's biggest hit.

196. What name is shared by an Ozzy Osbourne album released in 1991, and a disco song released in 1979?

 A. Le Freak
 B. September
 C. No More Tears
 D. Night Fever

Answer: C. No More Tears

"No More Tears" marked the last Ozzy Osbourne album to feature Randy Castillo on drums and longtime bassist and songwriter Bob Daisley. Motorhead's Lemmy Kilmister co-wrote four songs for the album, including "Hellraiser" (who also released the song on Motorhead's 1992 album "March or Die") and the wildly popular ballad "Mama, I'm Coming Home". Following the end of the subsequent "No More Tours" tour (originally set to be Ozzy's final tour), opening act Alice In Chains hired touring bassist Mike Inez, who remains in the group to this day.

197. Which following Alanis Morissette song was not from her "Jagged Little Pill" album?

 A. Uninvited
 B. Forgiven
 C. You Learn
 D. Head Over Feet

Answer: A. Uninvited

Recorded for the 1998 "City of Angels" soundtrack, "Uninvited" marked Morissette's first new release since her 1995 debut, the internationally renown "Jagged Little Pill". A low-quality recording of "Uninvited" was circulated around the internet in early '98, which prompted Warner Brothers Music to officially release the song as a single months before the soundtrack's release date. "Uninvited" was nominated for

three grammy awards in 1999, winning two of them. The song has sold over 7 million copies worldwide and remains one of Morissette's most popular efforts.

198. The cover art of "The Fat of the Land" by The Prodigy features which animal, gesturing aggressively?

 A. Octopus
 B. Shark
 C. Starfish
 D. Crab

Answer: D. Crab

After the original album art for 1997's "The Fat of the Land" was rejected at the last minute by The Prodigy's leader, songwriter, and keyboard player Liam Howlett, Alex Jenkins frantically got to work designing a new album cover. Using a photograph of a blackback land crab taken in Costa Rica, Jenkins digitally altered the left claw to make it larger for added effect. The last minute cover proved to be the perfect artwork for the band's breakthrough album, which spawned three singles, a Grammy nomination and sales of over 10 million units worldwide.

199. The cover of Hole's 1994 'Live Through This' album features model Leilani Bishop dressed up as what type of character?

 A. A prom queen
 B. A nun
 C. A witch
 D. A nurse

Answer: A. A prom queen

Frontwoman Courtney Love stated that she wanted the album cover to depict the moment of crowning of a prom queen and the emotions of the moment of victory. "Live Through This" marked the band's transition from their raw, unrefined punk beginnings to a more radio-accessible mainstream sound. Released five days after the 1994 suicide of Love's husband Kurt Cobain, the album was met with international acclaim, quickly going double platinum.

200. UK band The Prodigy became known for their logo that featured which insect?

 A. Butterfly
 B. Lady bug
 C. Bee
 D. Ant

Answer: D. Ant

The Prodigy's leader, keyboardist, and songwriter Liam Howlett has stated that the band began using the ant for the band's logo in1995, saying that they're "small and powerful", and alluding to the symbolism that "you might not hear from us for a bit... But if you look closely we are always there". With the signature ant logo showing up on many of the bands album covers, the logo is still used extensively on the band's merchandise to this day.

201. Which of the following bands did not contribute to the 1988 "Sub Pop 200" compilation?

 A. Green River
 B. Fastbacks
 C. Nirvana
 D. Alice In Chains

Answer: D.Alice In Chains

The "Sub Pop 200" compilation was released in 1988 during the early years of the Seattle grunge rock scene. The compilation features songs by 20 different bands including Tad, Nirvana, Mudhoney, The Walkabouts, Soundgarden, Blood Circus, and Chemistry Set among others. The 1990s alternative rock scene was heavily influenced by many of these bands

The band, Soundgarden, had several different bass players throughout the years that they were together.

202. As a veteran of the Seattle music scene. Which of the following bands did Van Conner never play with?

 A. Solomon Grundy
 B. Screaming Trees
 C. Mad Season
 D. Beat Happening

Answer: C. Mad Season

Van Conner never played with "Beat Happening". When Van was in highschool, He formed the band "Explosive Generation" with his brother Gary Lee Conner and friend Mark Pickerel. "Explosive Generation" later became the band "Screaming Trees" featuring Mark Lanegan on lead vocals. Conner later formed the bands Soloman Grundy, Valis, and Musk Ox.

203. Which of the following bands did not originate from the Seattle grunge rock music scene

 A. Mother Love Bone
 B. Sunny Day Real Estate
 C. Green River

D. The Smashing Pumpkins

Answer: D. The Smashing Pumpkins

The Smashing Pumpkins were formed in Chicago in 1988. The original band members included the frontman Billy Corgan on lead vocals and guitar, D'arcy Wretzky on the bass, James Iha on guitar, and Jimmy Chamberlin on drums. The Smashing Pumpkins are credited with breaking into the music mainstream with the release of their second album, Siamese Dream, in 1993.

204. Imaginary records released a Velvet Underground tribute album in 1993 entitled "Fifteen Minutes" What song did the Screaming Trees record for that album?

 A. She's my best friend
 B. What goes on
 C. Pale Blue Eyes
 D. I heard her call my name

Answer: B. What goes on

The 14 track album also features "Foggy Notion" by Echo and the Bunnymen, "Sunday Morning" by James, and "Here she comes now" by Nirvana. All of the Tracks on "Fifteen Minutes" had previously been released on the three-volume Velvet Underground tribute album called "Heaven & Hell".

205. Who said that he wanted to do something like The Beatles did with their album "Sgt. Peppers Lonely Hearts Club Band", which in his own words "was a massive progression"?

 A. Eddie Vedder
 B. Chris Cornell
 C. Scott Weiland

D. Kurt Cobain

Answer: D. Kurt Cobain

In Kurt Cobain's words, he said quote "I want [Nirvana] to progress. I really want to change our style of music. I want to do something different, really different. And I want to have enough guts to do that, and if it alienates people that's too bad. Not to compare us to The Beatles, but they went from 'I Want to Hold Your Hand' to Sgt. Pepper y'know and that was a massive progression, and I just want to experiment."

206. Which of the following bands did not include one of Soundgarden's former bass players?

A. Mudhoney
B. Truly
C. Nirvana
D. Hater

Answer: A. Mudhoney

The band, Hater, included Ben Shepherd who played with Soundgarden on the 1991 studio album Badmotorfinger, the 1994 studio album Superunknown, the 1996 studio album Down on the Upside, and the 2012 studio album King animal . Hiro Yamamotto played the bass with the other founding members of Soundgarden, Chris Cornell and Kim Thayil. He played with Soundgarden from 1984-1989 and later founded the band "Truly" and the band "Stereo Donkey". Jason Everman played the bass briefly for Soundgarden in 1990. Previously, he had toured with Nirvana in the summer of 1989 to promote Nirvana's album "Bleach". In 1993, Everyman played guitar with the band "Mind Funk" before joining the US army in 1994.

207. What is the first EP in music history to debut at Number 1 on the Billboard's 200 chart?

A. Alice In Chains - "Jar of Flies"

B. My Bloody Valentine - "Tremolo"

C. Slowdive's self-titled EP "Slowdive"

D. Pavement - "Watery, Domestic"

Answer: A. Alice In Chains - Jar Of Flies

Jar of Flies was Alice in Chains' third studio EP released in 1994 through Columbia Records. The first week of sales exceeded 141,000 copies in the US. The EP was self-produced at the London Bridge Studio in Seattle all in one week. In 1995, the single "I Stay Away" was nominated for two Grammy Awards in the categories of Best Recording Package and Best Hard Rock Performance.

HOW TO EASILY CONTRIBUTE A REVIEW

I hope you enjoyed The Ultimate 90's Alternative Rock Quiz Book. I'd kindly like to ask you to leave a brief review on Amazon.

Reviews aren't easy to come by, but they have a profound impact. So I would be incredibly thankful if you could just take a minute to leave a quick rating and/or review on the product page, even if it's just a sentence or two!

To do so, just scroll to the bottom of the product page and click on the following button:

Write a customer review

This will take you to the "Create Review" page where you can enter your star rating and then write a sentence or two about the book.

It's that simple!

My sincere appreciation as your review makes a difference.

~ Jon Marshall

THANK YOU!

I hope you enjoyed, and don't forget to give the book a quick rating or review over on Amazon! I'll leave you with a simple yet favorite lyric of mine which I believe sums up the 90's angst and energy:

I can't help the feeling, I could blow through the ceiling
~ RADIOHEAD: FAKE PLASTIC TREES